hidden SONOMA

PHOTOGRAPHS BY WES WALKER

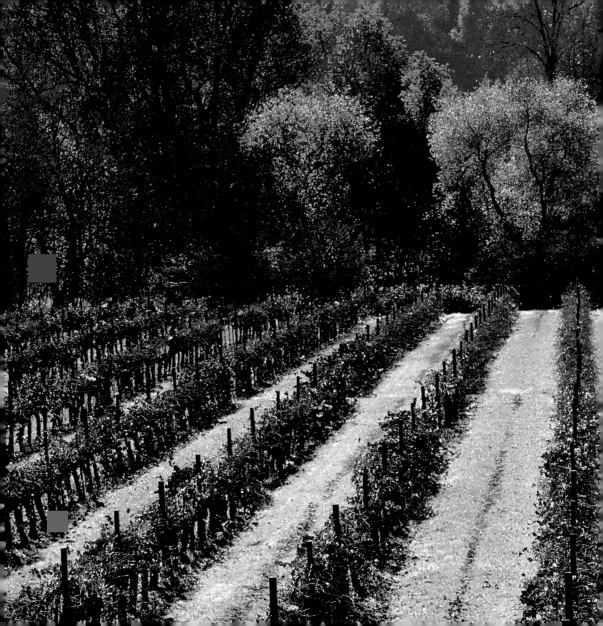

hidden SONOMA

PHOTOGRAPHS BY WES WALKER

welcome
BOOKS

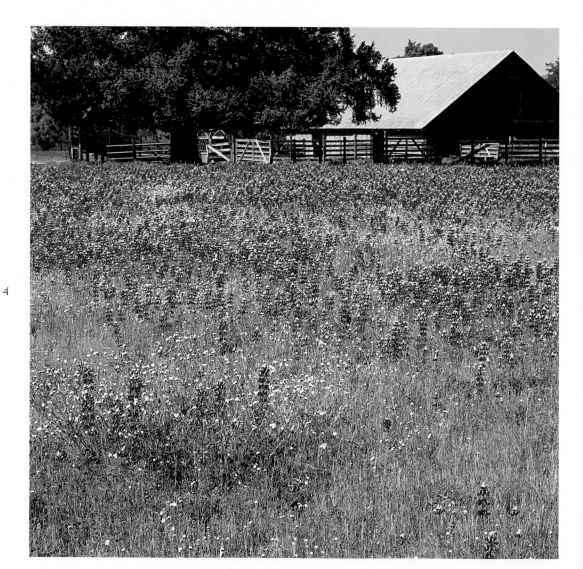

4

Sonoma County, its profoundly different cultures, the diversity of its land-scape and its stark beauty, perhaps, more than any other place, reflects the true essence of California. Rich in history with the early Russian settlement on the North coast, the arrival of the Spanish in Sonoma to establish the last mission, the creation of its dairy, cattle, and lumber industries in the mid-1800s, and the growing of apples and raising of chickens in the early 1900s, it has grown and prospered without losing its robust and vital individuality. Today it is a place in transition with its expanding vineyards, the crafting of fine wines, and an incipient olive oil industry. It has become the source of much of the organic produce and specialty food items that have spawned California Cuisine. The rugged coast, the redwood forests drenched with fog, and its verdant valleys and mountain ranges, all enhance and enrich the environment and the lifestyle of Sonoma's people. I have attempted to capture this essence and to preserve, for at least this moment of time, the beauty of its landscape, the endeavors of its people, and its success. Enjoy!

WES WALKER

A Russian River Valley setting affords J Vineyards and Winery its unique combination of soil diversity and cool coastal fog. This enables the fruit to mature slowly for ideal aroma and wonderful flavor complexities. *(preceding spread)*

Wild lupines fill a field in Knights Valley. Aside from the natural wildflowers in the region, winemakers often plant organic cover crops, such as crimson poppies, fava beans, purple vetch, and other legumes, which provide natural sources of nitrogen in the vineyard and eliminate the need for insecticides. *(opposite)*

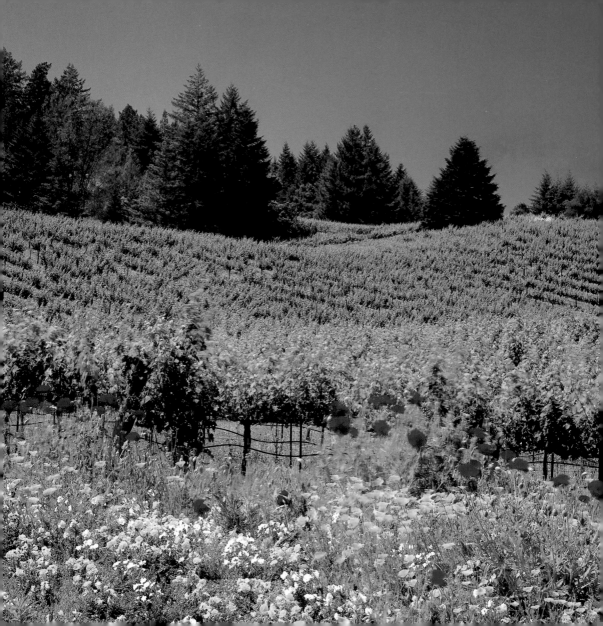

spring

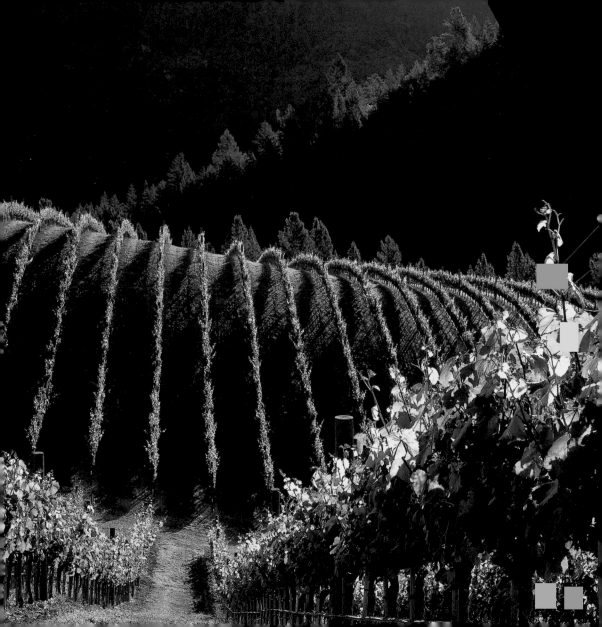

SONOMA Valley hums with the fruits of its labor. Grapevines rise and fall along the surrounding hillsides in perfectly ordered rows, like the sinewy staves on a vast piece of sheet music.

—Bruce Newman,
travel writer

Two professional actors, Raymond Burr and Robert Benevides, started Raymond Burr Vineyards in 1986. The Dry Creek Valley winery also grants visitors a look at the pair's work with hybrid orchids—they have created 2,000 new varieties. *(preceding spread)*

Located on the slopes of Mount St. Helena, Peter Michael Winery takes pride in the unique flavors produced from hillside fruits for its Chardonnay, Cabernet Sauvignon, Pinot Noir, and Sauvignon Blanc. *(opposite)*

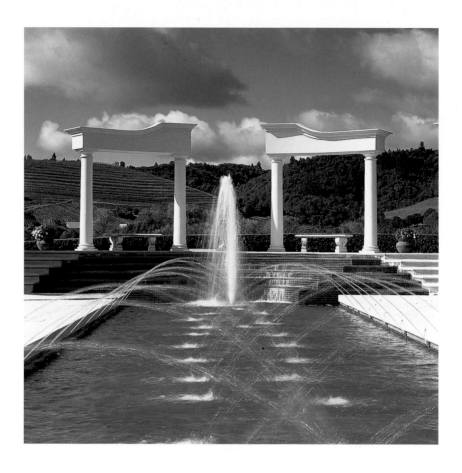

The beautiful vistas of Ferrari-Carano's Dry Creek Valley estate vineyards are framed at
Villa Fiore, the winery's hospitality center, by majestic fountains and pillars. The winery's exclusive
Villa Fiore wines include Pinot Noir, Syrah, Cabernet, Chardonnay, and Grenache Rosé.

Spring blossoms in one of the many serene gardens surrounding Villa Fiore. The keystone path
winds through five acres of gardens filled with benches, waterfalls, and a small stream. *(opposite)*

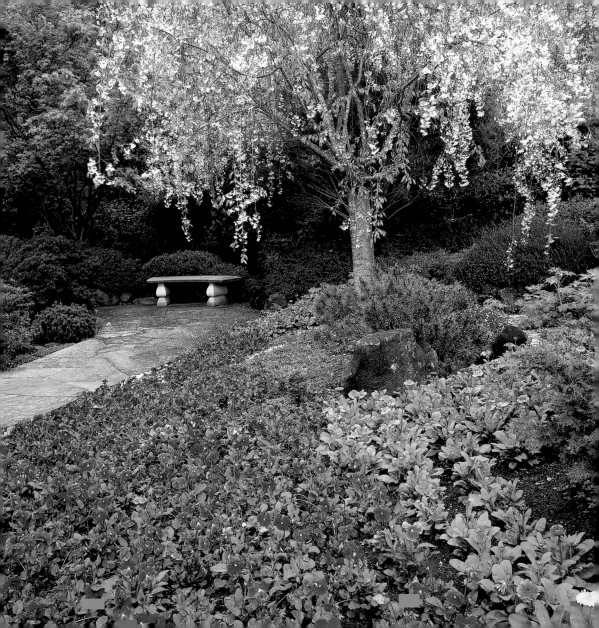

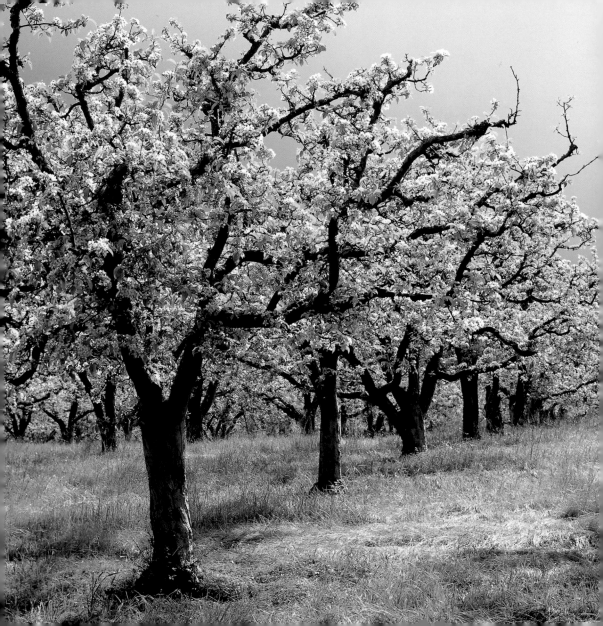

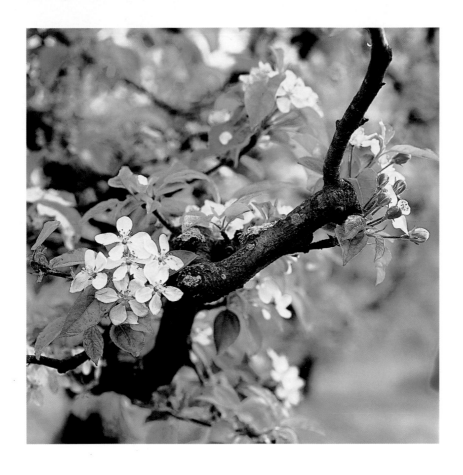

Whites, yellows, and pinks brighten an apple tree branch. Sonoma County grows
a variety of apples, including Gravenstein, Red Delicious, McIntosh, and Rome.

Blooming apple trees in Sonoma. Most of Sonoma County's 40,000 annual tons of apples are sold for juice. *(opposite)*

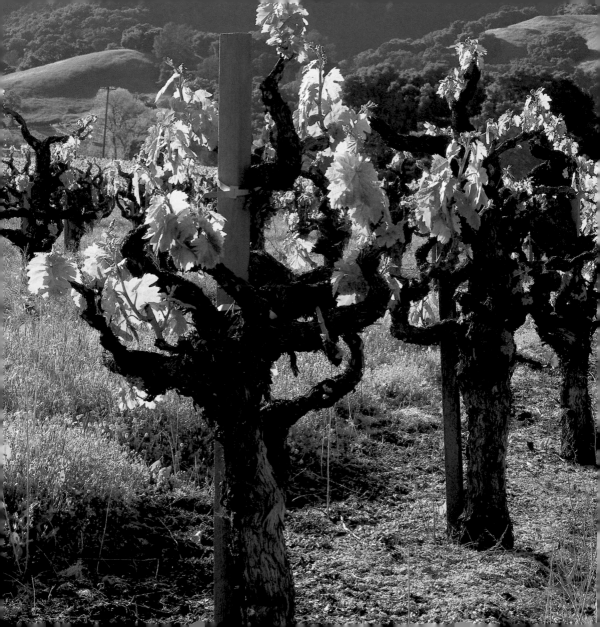

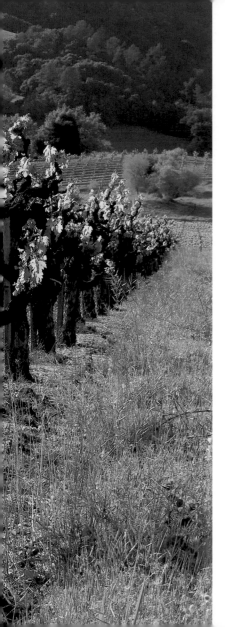

I can no more think of my own life without thinking of wine and wines and where they grew for me and why I drank them when I did and why I picked the grapes and where I opened the oldest procurable bottles, and all that, than I can remember living before I breathed.

—M. F. K. Fisher,
food writer

A row of Old Zinfandel vines in Alexander Valley.

THIS is spring in Wine Country, this

beginning of the battle against Mother Nature,

or rather, Mother Nature testing our mettle.

—Robert Brittan,
winemaker

Morning fog rises off the Pacific at Salt Point State Park. The 6,000–acre facility
features an underwater park, camping, picnicking, fishing, scuba diving, hiking, and riding.

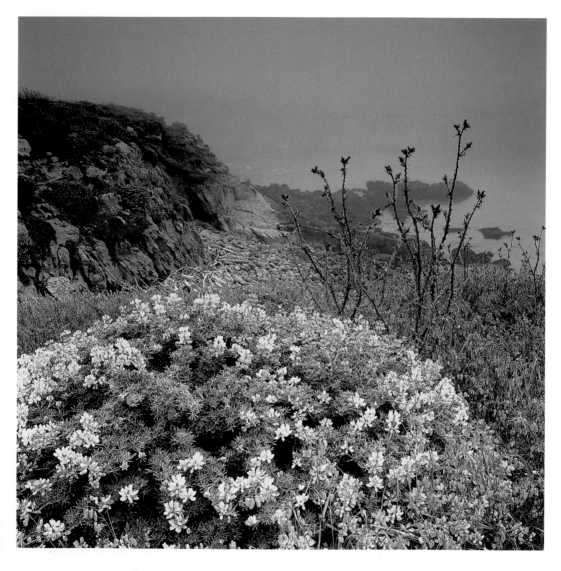

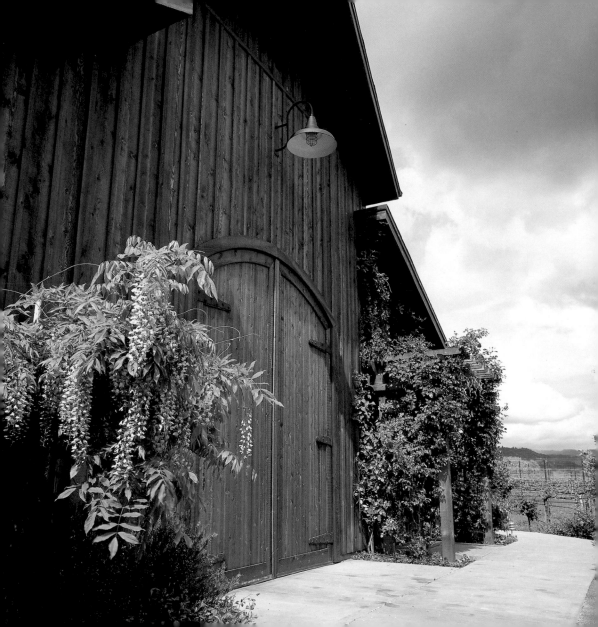

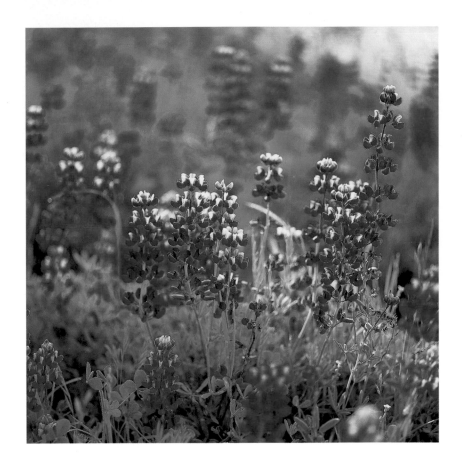

Beautiful wild purple lupines fill Knights Valley every spring.

The tasting room at De La Montanya Winery in Dry Creek opened in 2003. Surrounded by Golden Delicious orchards, the tasting room provides visitors a sample of award-winning De La Montanya Russian River Valley Estate wines: Viognier, Chardonnay, and Pinot Noir. *(oppposite)*

WINE makes daily
living easier, less hurried,
with fewer tensions and
more tolerance.

—Benjamin Franklin

A vineyard along Sweetwater Springs Road, which winds between Guerneville and Healdsburg.

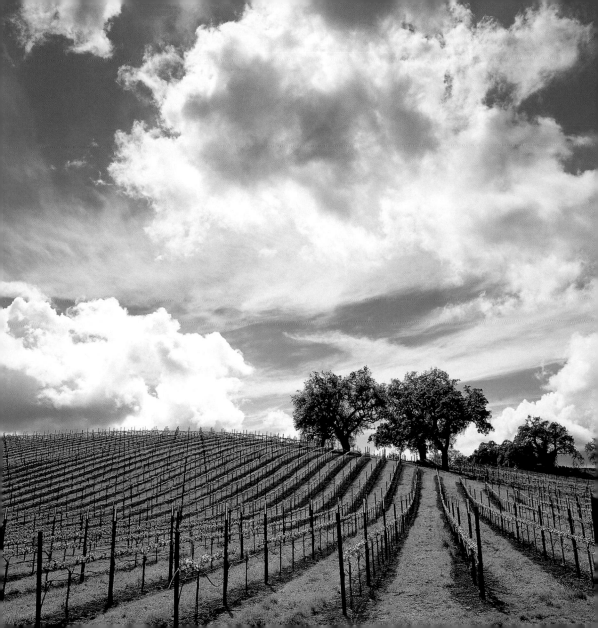

THE Alexander Valley is a feast of color. The blue-gray Russian River meanders through the lush green of the valley floor. Red loamy soils give way to golden hillsides, with Mount St. Helena and Geyser Peak like granite sentries, guarding the north and south ends of the valley.

—Chris Hanna,
Hanna Winery

Jordan Vineyard & Winery's Cabernet Sauvignon and Chardonnay are bottled at the estate. First, though, they must go through Jordan's delicate process of winemaking, which includes aging young wines in a combination of French- and American-oak barrels.

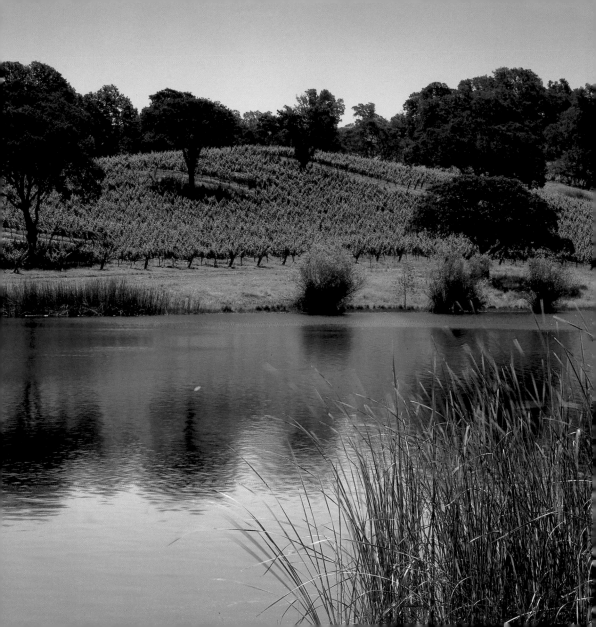

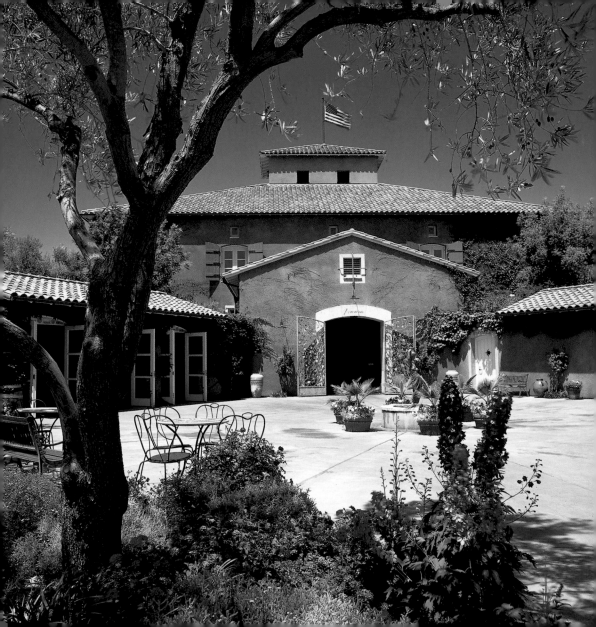

Warm tones of brown and gold give the entrance to the Viansa Cellar
a romantic Italian sensibility, as do the candles and ornate ironwork.

The courtyard of Viansa Winery has a rich Tuscan feel. Tables with a view of the Viansa Wetlands
allow visitors to relax amid the Mediterranean flora and statues imported from Italy.
Viansa also offers tastes of its lesser-known wines, such as Arneis, Aleatico, and Primitivo. *(opposite)*

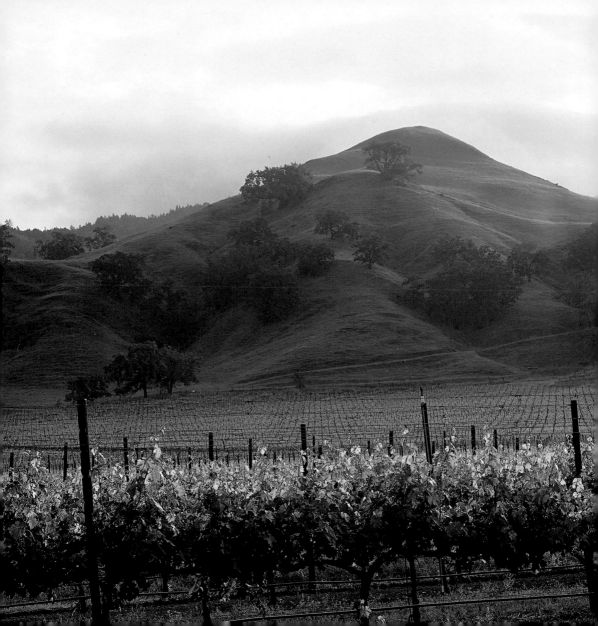

THERE is no time like Spring,

When life's alive in everything.

—Christina Rossetti

Sunrise over Mount St. Helena slowly lights up one of Beringer's many vineyards.
Founded by two brothers from Germany, the winery still ages wines such as Knights Valley
Cabernet Sauvignon in tunnels built by Chinese transcontinental railroad workers.

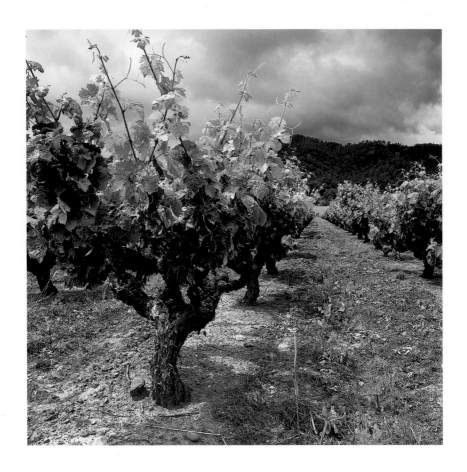

An Old Zin vine in Alexander Valley. One of the first vines to be planted in the region, Zinfandel amounted to more than half of the area's 1,500 acres of vines by 1885.

At the entrance to the Robert Young Vineyards and Winery, a road winds by the large, old-fashioned tasting room to the family's farmhouse and 500 acres of land. The Youngs grow 13 varieties of grapes at their Alexander Valley vineyards. *(opposite)*

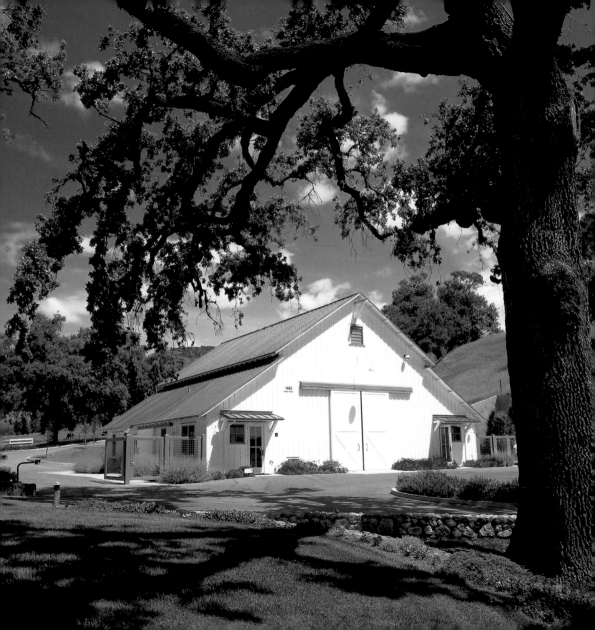

UNLIKE smaller,
more manicured Napa,
Sonoma is a dramatic
Rhode-Island-and-a-half
of craggy ocean cliffs,
TV-Western ranchland
and shadowy redwood forests.

—Richard Nalley,
food writer

Fort Ross was originally established in 1812 as an
outpost for sea otter hunters from Russia. The church
has been rebuilt twice, in 1916 and again in 1970,
and was the first Orthodox church south of Alaska.

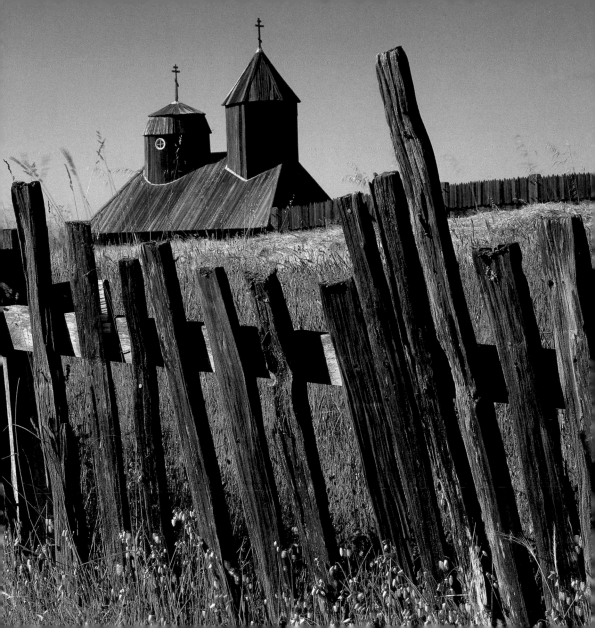

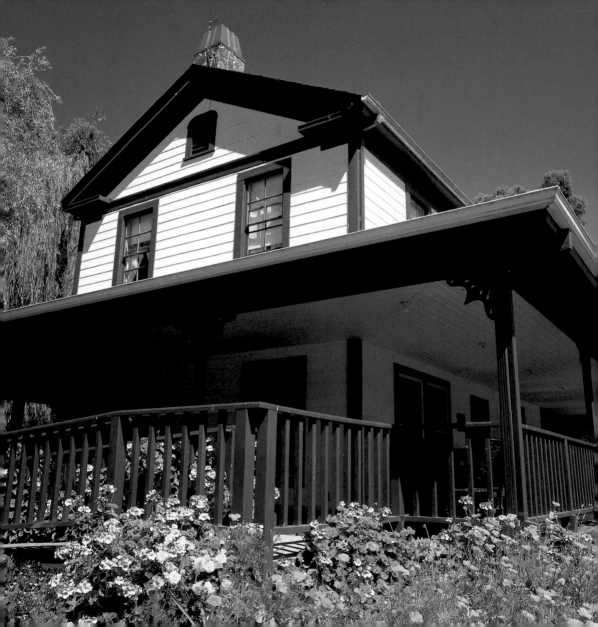

Weeping willow trees and rosebushes line the gardens around Cline Cellars in Carneros. Owner Fred Cline pioneered the planting of Rhône varietals—including Syrah, Viognier, Marsanne, and Roussanne—in the area.

The tasting room at Cline Cellars is found inside a charming 1850s farmhouse surrounded by six spring-fed ponds and lush picnic areas. *(opposite)*

VINEYARDS are the

heart of every great winery.

—Rodney Strong,
winemaker

Gloria Ferrer Champagne Caves was the first sparkling winery
established in the Carneros. It was designed with the owner's Spanish homeland
in mind, incorporating red-tile roofs and hacienda-style archways.

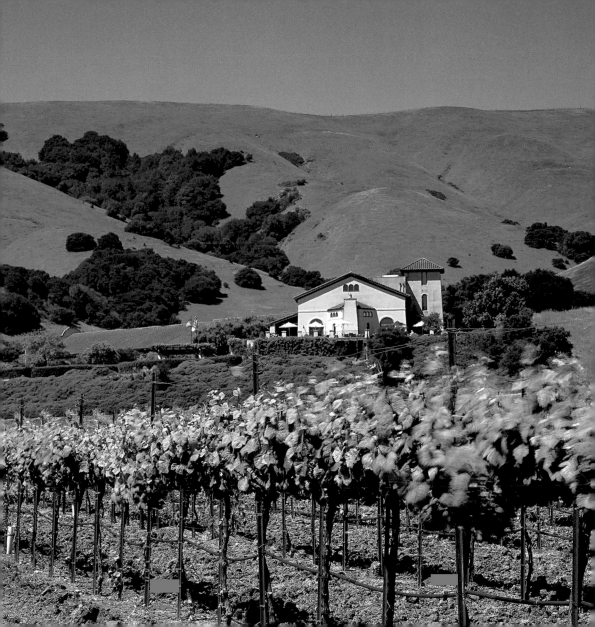

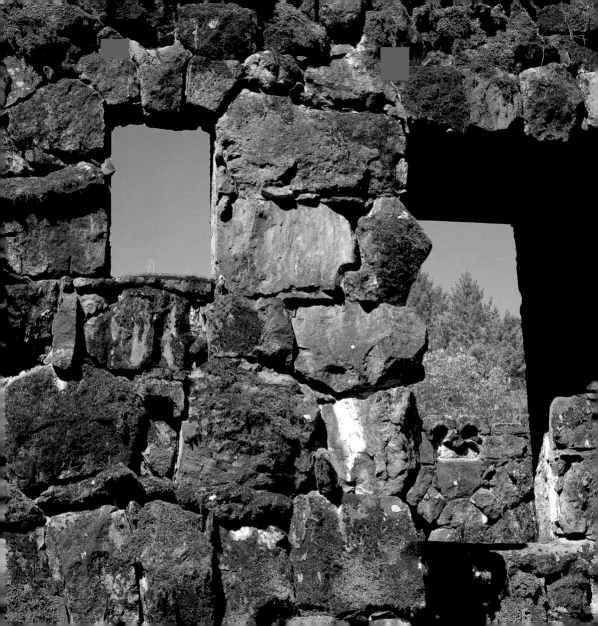

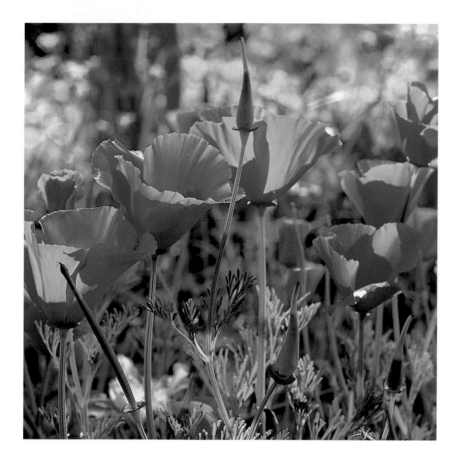

Orange poppies signal that another spring has come to Jack London State Historic Park, once part of the writer's 1,500-acre Beauty Ranch. During his time at the Glen Ellen Ranch, London wrote *Burning Daylight* (1910), *Valley of the Moon* (1913), and *Little Lady of the Big House* (1916).

A tree peeks through the remains of Jack London's Wolf House. London's dream home was made of volcanic rock, redwood, blue slate, and Spanish tile. Before it was completed, it was destroyed by a fire in 1913, three years before London's death. *(opposite)*

SPRING is my favorite time of the year in the vineyards and gardens at our ranch near Windsor. Everything is just so lush and colorful, from the pink magnolias lining the driveway to the purple rhododendrons under the oak trees.

—Saralee McClelland Kunde,
grape grower

Kunde Estate Winery & Vineyards in Kenwood. Of the 800 acres of vineyards, the Shaw Vineyard block of 122-year-old Zinfandel still produces fruit for Kunde's Century Vines Zinfandel.

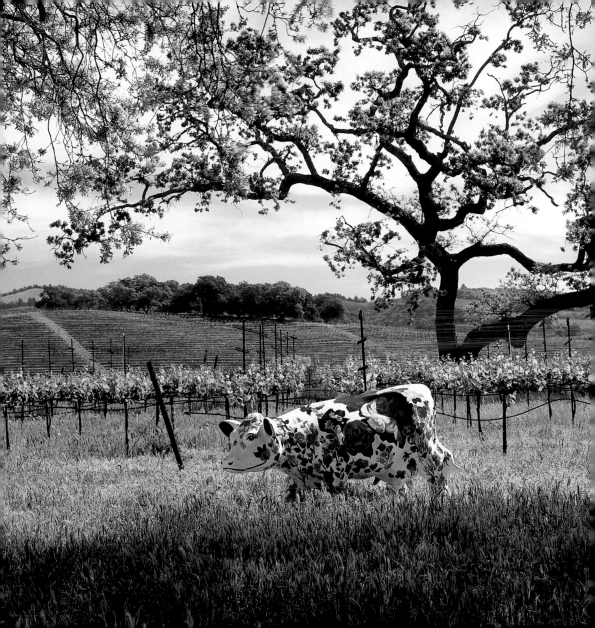

SPARKLING and
bright in the liquid light
does the wine our goblets
gleam in; with hue as red
as the rosy bed which a bee
would choose to dream in.

—Charles Fenno Hoffman,
poet

Bright red poppies and yellow wildflowers grow
between the rows at a vineyard in Knights Valley.

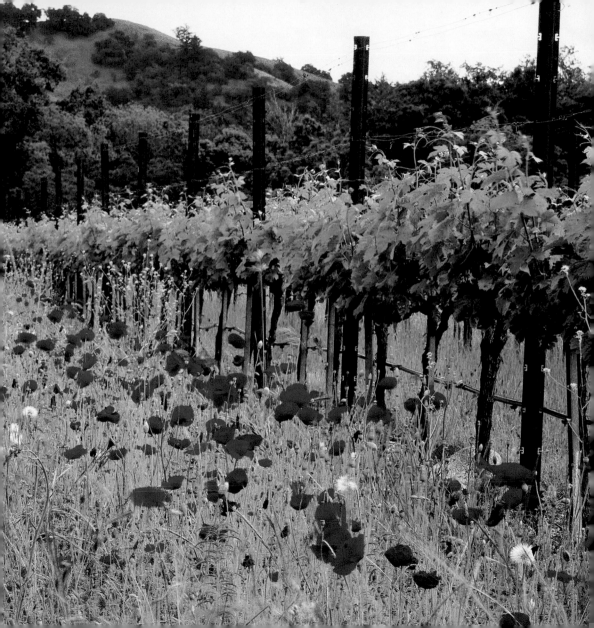

THERE are days when the stealthy grayness fills the valley, rolling over the redwoods, moving into the folds of Rockpile Ridge. As I watch the fog moving everywhere around me, I wonder how can so much be happening and yet, there is no sound.

—Jack Florence,
grape grower

The pond at Jordan Vineyard & Winery is part of an informal preserve for wildlife including deer, wild turkeys, coyotes, and waterfowl. The winery emphasized architecture, landscaping, gardens, hospitality, and cuisine when designing its estate in the early 1970s.

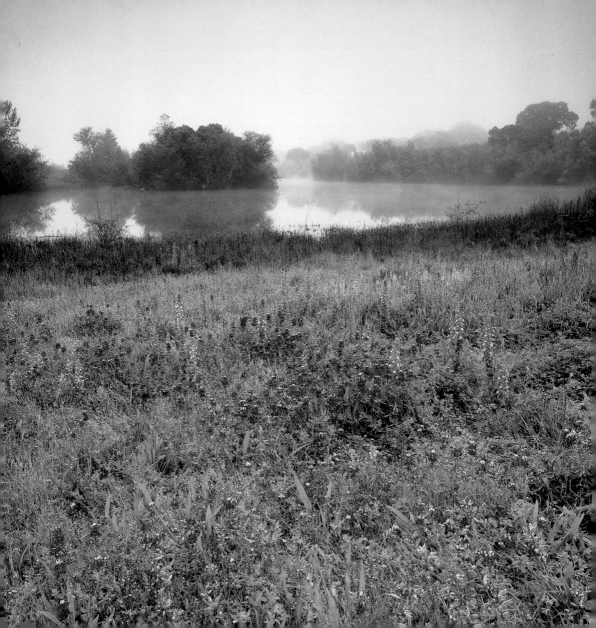

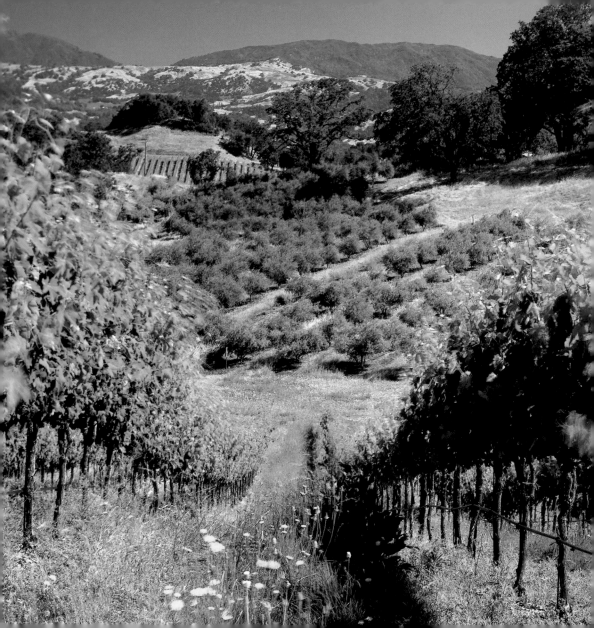

summer

THE best things in life are nearest:

Breath in your nostrils, light in your eyes,

flowers at your feet, duties at your hand,

the path of right just before you.

Then do not grasp at the stars,

but do life's plain, common work as it comes,

certain that daily duties and daily bread

are the sweetest things in life.

—Robert Louis Stevenson

One of the primary goals at the Jordan Vineyard & Winery is to produce wines in elegant surroundings, continuing the European tradition of winemaking. *(preceding spread)*

Built in 1905, the Hop Kiln Winery in the Russian River Valley is a historic landmark as well as a winery and tasting room. It produces unique blends such as Rushin' River Red, comprising of 37 percent Syrah, 30 perecent Cabernet Sauvignon, 23 perecent Zinfandel, and 10 perecent Dolcetto. *(opposite)*

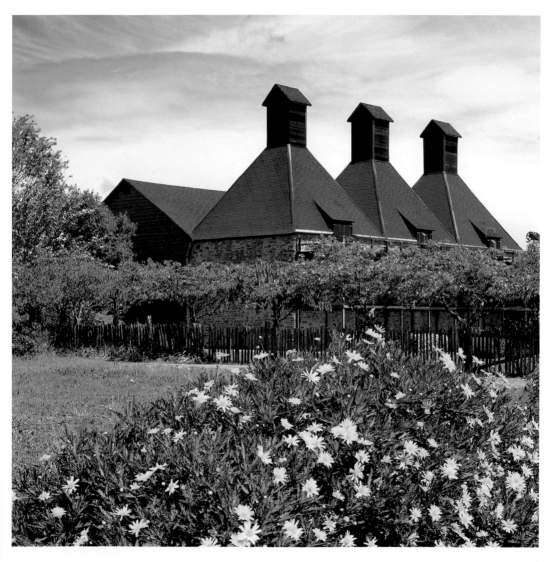

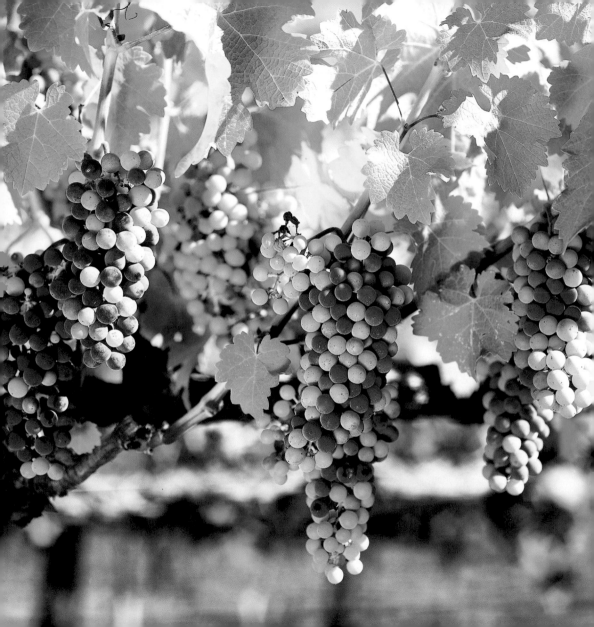

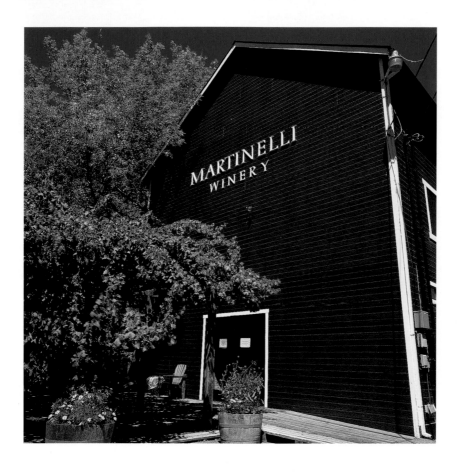

The Martinelli Winery has passed through five generations of the Martinelli family,
producing 8,000 cases of wine annually from 100-year-old vineyards.

Cabernet grapes at Silver Oak have reached verasion, the critical time in a grape's
life when it begins to ripen and change color. Grape growers must ensure that the vine
is not overwatered, because the grapes can plump up too much. *(opposite)*

ALL the eastern sky was blushing to rose,

which descended upon the mountains,

touching them with wine and ruby.

Sonoma Valley began to fill with a purple flood,

laying the mountain bases, rising, inundating,

drowning them in its purple.

—Jack London

This lavender field is part of the expansive fields and unique gardens at Matanzas Creek
Winery, which sowed more than 4,500 lavender plants in 1991. Aside from being visually stunning,
the lavender helps drain the soil, moving excess water away from the grapevines.

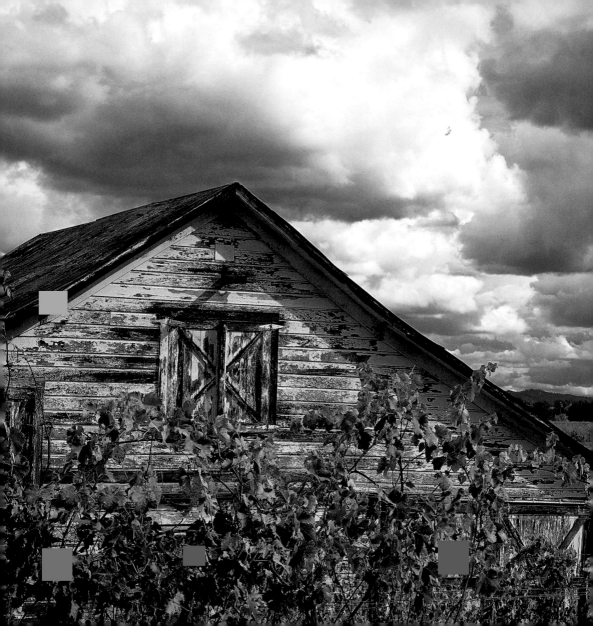

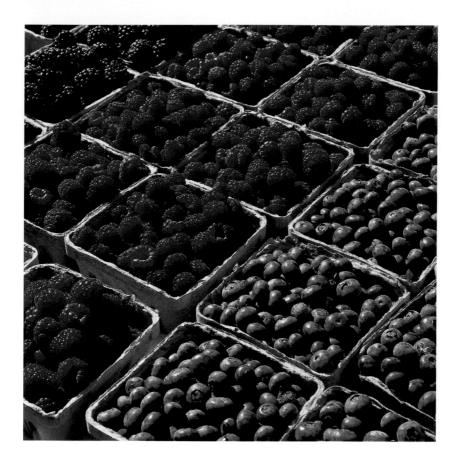

Berries are only a small part of the offerings at Healdsburg Farmer's Market—leisurely socializing, discussions of recipes with the farmers and other shoppers, and searching for rare produce help define the experience.

A weathered barn on Westside Road, Dry Creek Valley. *(opposite)*

Clouds sweep over magnificent rows of vines in Dry Creek Valley. *(overleaf)*

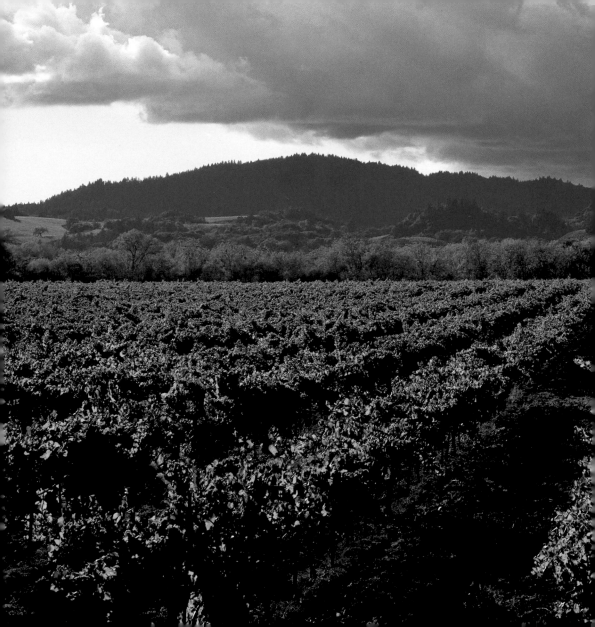

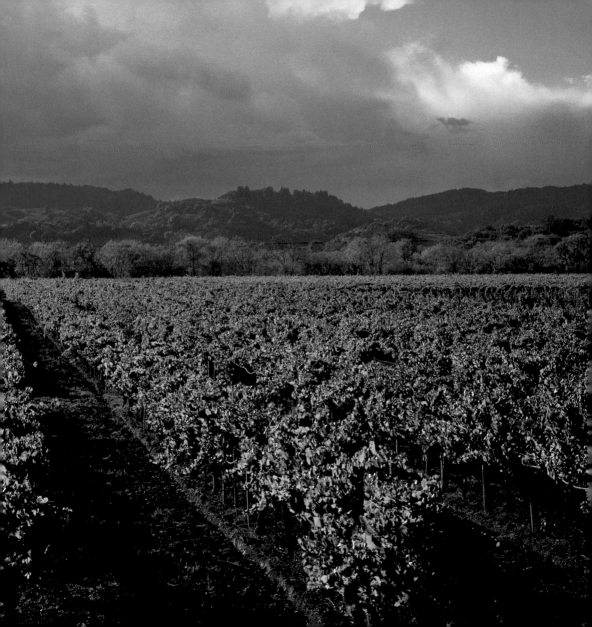

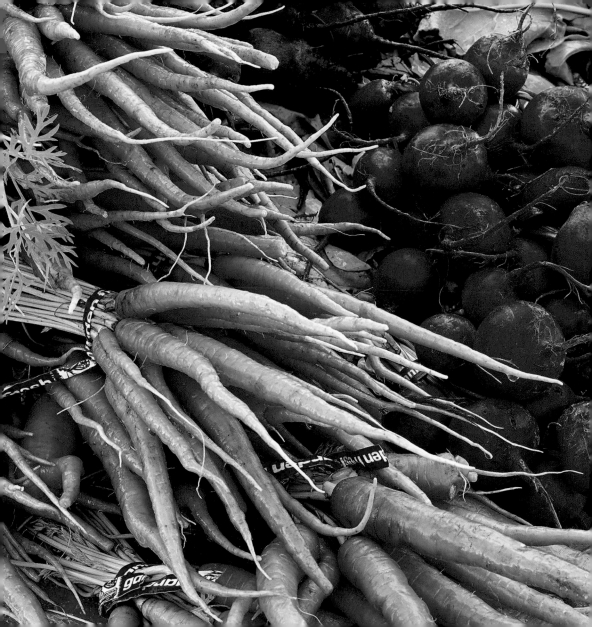

LIKE the circular rhythm
of nature that leads to harvest,
there's a natural wheel or cycle
created by Wine Country chefs
and their growers and purveyors.

—Diane Peterson,
writer

Carrots and other vegetables from Orchard Organic Farm in Sebastopol at the Healdsburg Farmers Market.

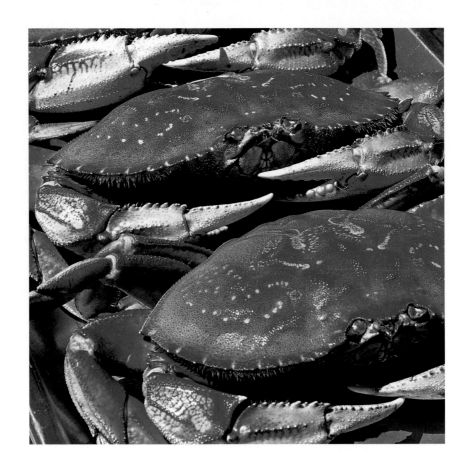

Crabs from Spud Point Crab Company are ready for eating at Spud Point Marina in Bodega Bay. Sportfishing is a popular tourist activity in the area, with ample opportunity to catch Dungeness crabs, rock cod, king salmon, and albacore.

Fishing boats at Bodega Bay. The town and surrounding area were made famous around the world by Alfred Hitchcock's 1963 film *The Birds. (opposite)*

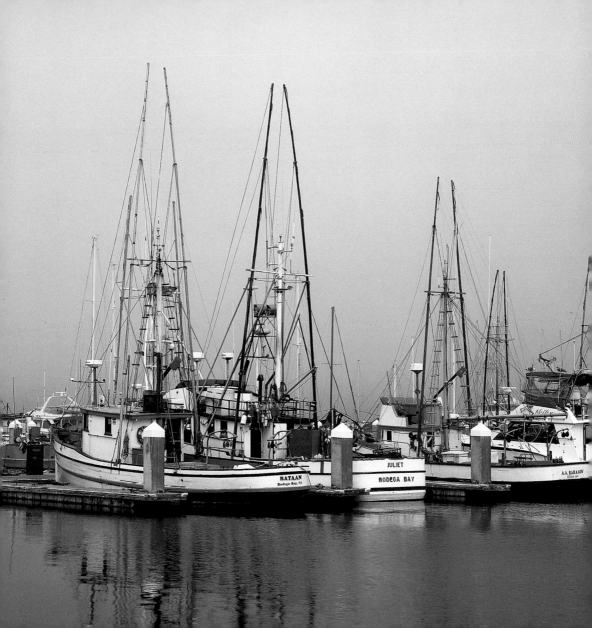

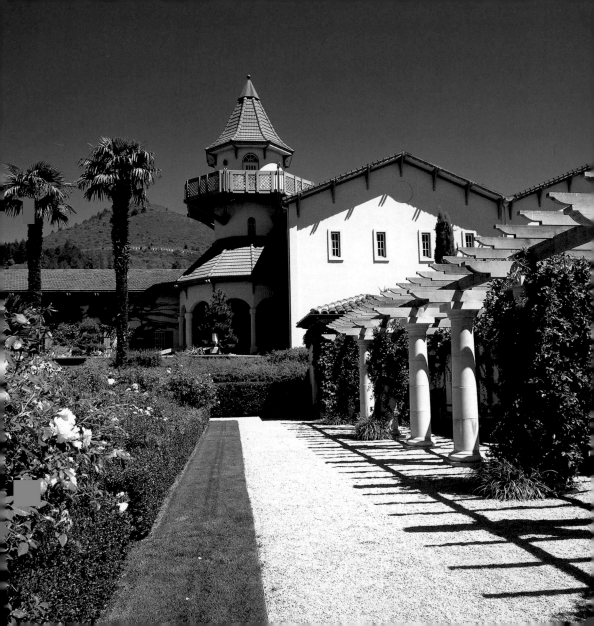

SONOMA Valley, a region
with so much rich wine history
and local flair that it has become
a veritable Mesopotamia in the
world of California wines.

—Christopher Sawyer,
writer

In the heart of Château St. Jean, the 1920s château itself boasts a magnificent
courtyard inspired by formal estate gardens in Italy and the south of France.

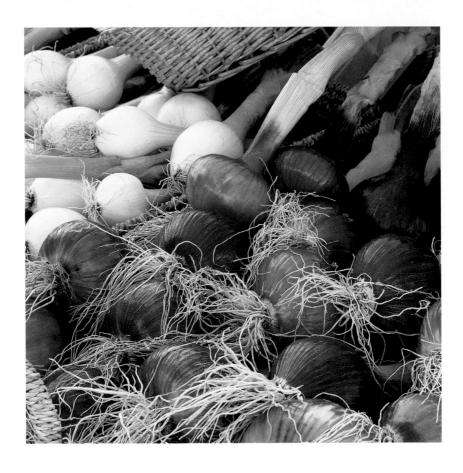

Organic onions from Middleton Farm in the Dry Creek Valley
show off their vibrant colors at the Healdsburg Farmer's Market.

The Freestone Store, in the small hamlet of Freestone, has served as the town's
merchandise mart, dance hall, meeting place, and post office for more than 128 years. *(opposite)*

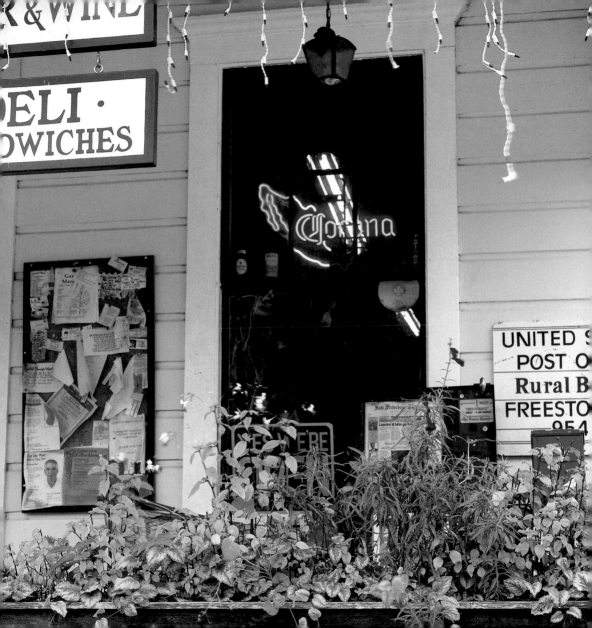

CALIFORNIA became the first
to discover that it was fantasy that led
to reality, not the other way around.

—William Irwin Thompson,
poet

Candy & Kites in Bodega Bay has been a local favorite since 1983. More than a dozen
flavors of saltwater taffy are for sale, as well as stunt, traction, and single-line kites.

EXCELLENT wine generates enthusiasm. And whatever you do with enthusiasm is generally successful.

—Baron Philippe de Rothschild,
winemaker

The 1850 home of General Vallejo, the commander of the northern Mexican frontier and founder of the Pueblo of Sonoma, was known as Lachryma Montis or "tears of the mountain." The name was derived from the springs that are the current source of Sonoma's water supply.

Red poppies burst with color at the base of Hanna Winery in the Alexander Valley. *(overleaf)*

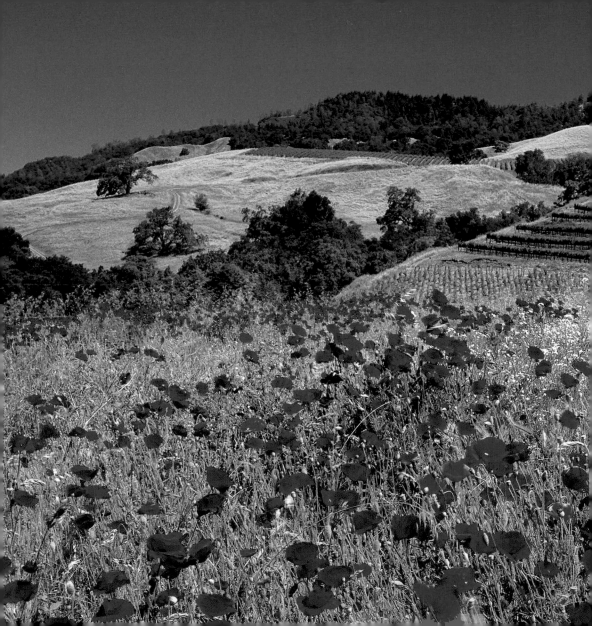

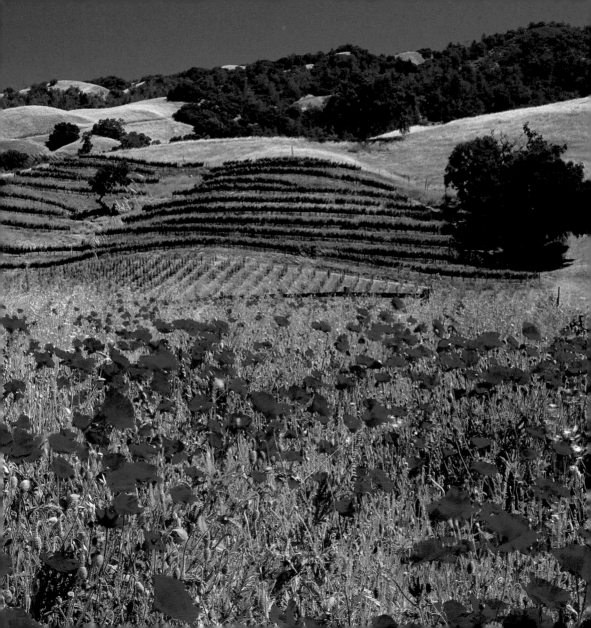

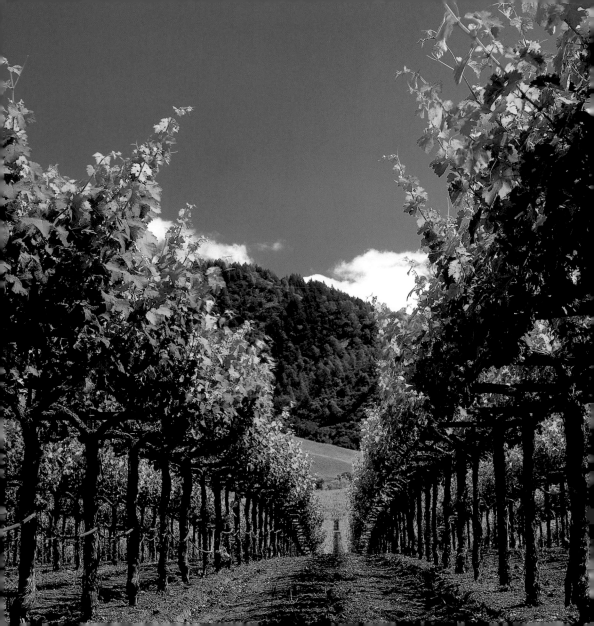

A search for the perfect postcard image of Wine Country inevitably leads to the Alexander Valley, which with its tawny hills and acres of neatly planted rows still looks largely the way it did a century and a half ago.

—Tim Tesconi,
local writer

In 1972, Alexander Valley Vineyards' harvest for Silver Oak Cellars became its first official Alexander Valley Estate vintage. Its 200 acres—planted with Cabernet Sauvignon grapes—today produce one of Sonoma's finest wines.

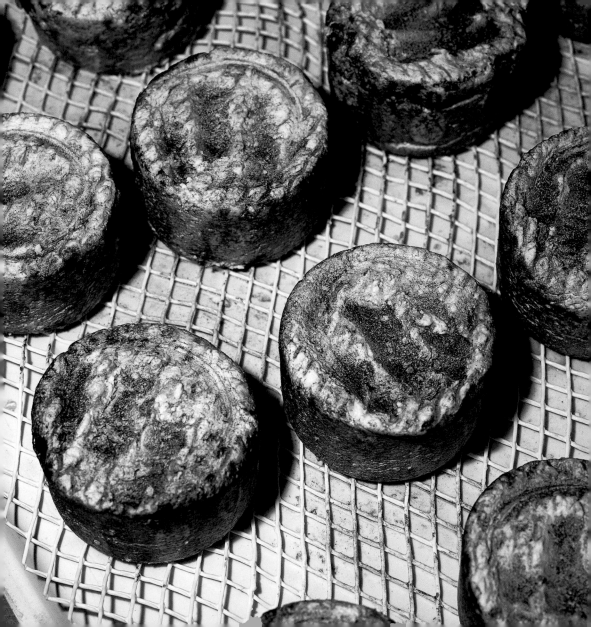

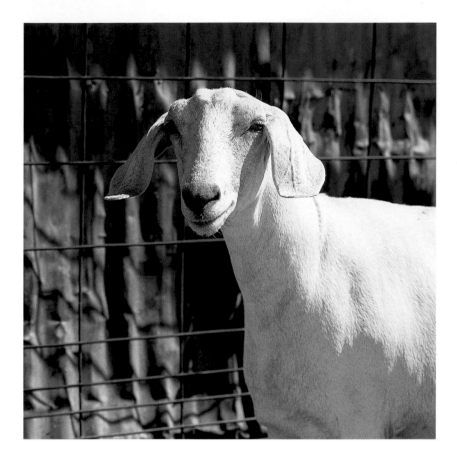

Nubian goats, one of the sources of famed Laura Chenel's Chèvre of Sonoma, were developed in England by crossing British goats with bucks of African and Indian origin.

The real thing: Laura Chenel's Chèvre in its aged form. The cheese is sold all over the country and is best paired with Sauvignon Blanc or Pinot Grigio. *(opposite)*

THERE is a way that
nature speaks, that land speaks.
Most of the time we are simply
not patient enough, quiet enough,
to pay attention to the story.

—Linda Hogan,
poet

Château Souverain is nestled on a vineyard-covered hilltop overlooking the Alexander
Valley. The winery was designed and built by architect John Marsh Davis in 1973.

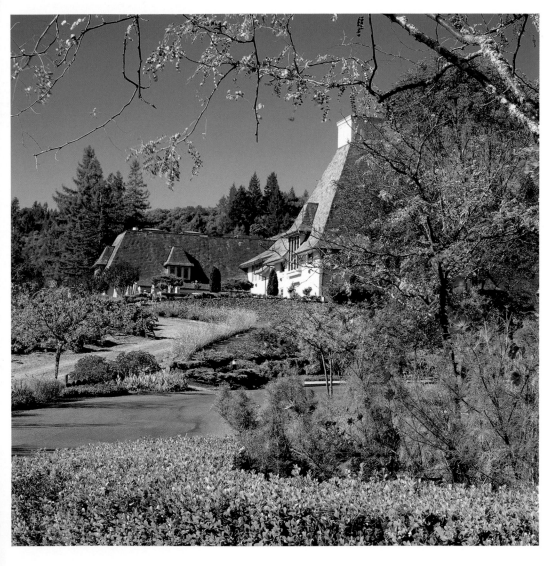

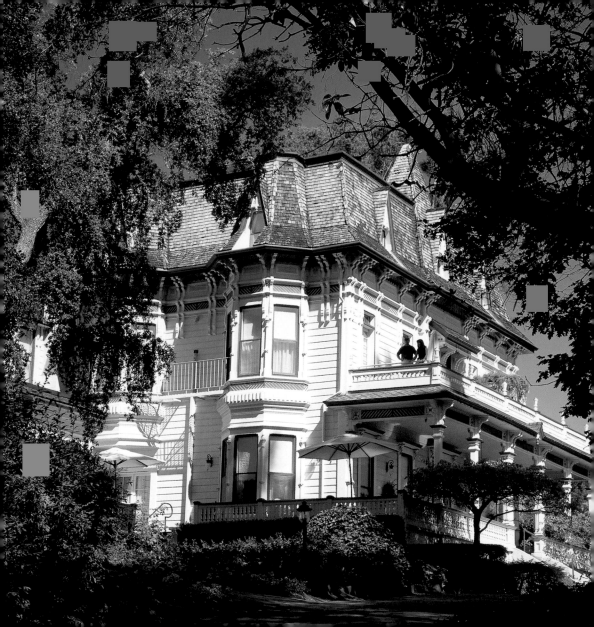

Chardonnay grapes in bloom.

Built in 1881, Madrona Manor is a romantic Victorian estate inn located in the midst of
wine country. With eight acres of wooded and landscaped grounds, as well as a veranda for drinks
and a fire for chilly Northern California nights, it's a marvelous weekend retreat. *(opposite)*

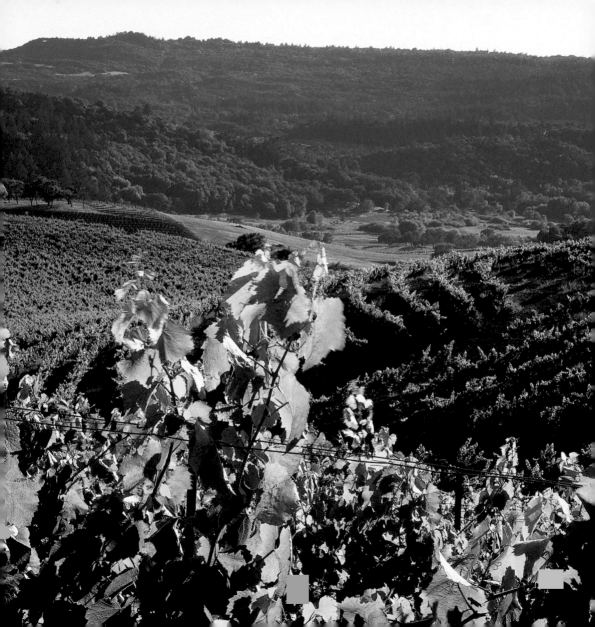

VINES love an open hill.

—Virgil

Kunde Estate Winery & Vineyards has two ranches,
each with several vineyards. Its wines include Kinneybrook
Chardonnay, Shaw Century Vines Zinfandel, C. S. Ridge
Chardonnay, Wildwood Chardonnay, Drummond Cabernet
Sauvignon, and Magnolia Lane Sauvignon Blanc.

SUMMER afternoon—Summer afternoon...

the two most beautiful words in the English language.

—Henry James

The 2,000-acre Kunde Estate Winery & Vineyard, nestled in the fabled Valley of the Moon beneath the Mayacamas Mountains, grows more than 20 wine grape varieties.

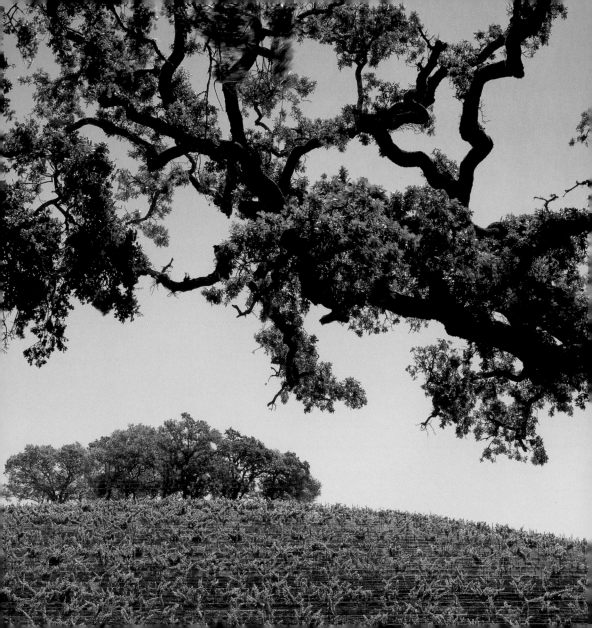

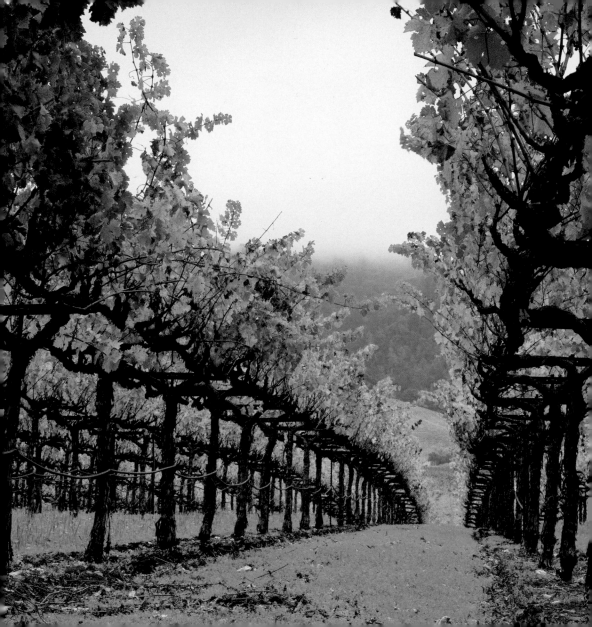

fall

SONOMA County is chaotic and geographically cumbersome, a region of tremendous diversity. There are many Sonomas, layered one upon the other, entwined, intermingled, and, in many cases, hidden.

—Michele Anna Jordan,
journalist

The leaves begin to fall in the rows of a Cabernet Sauvignon vineyard at Silver Oak Cellars. Before founding the winery in the early 1970s, the Duncan family owned and operated an eclectic mix of businesses including an oil and gas exploration company, a ski resort, and a buffalo ranch. *(preceding spread)*

Fall arrives at a vineyard by Westside Road in Sonoma.

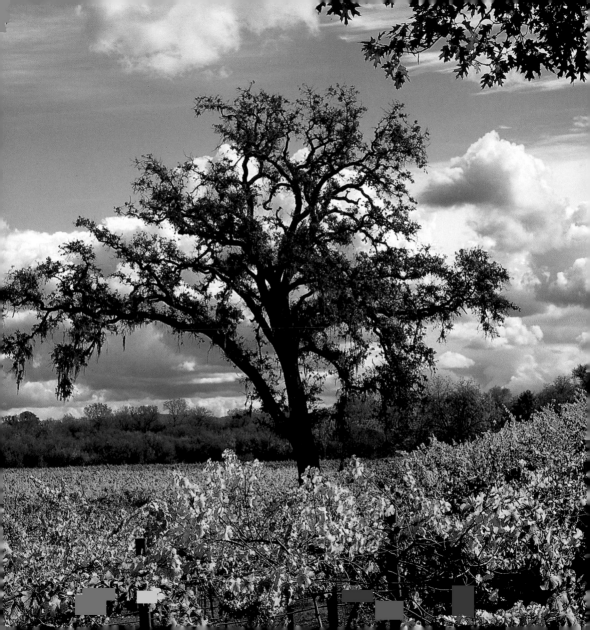

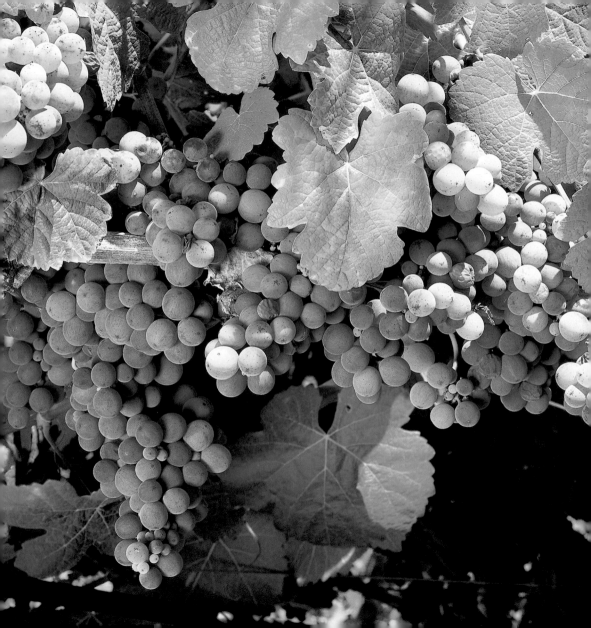

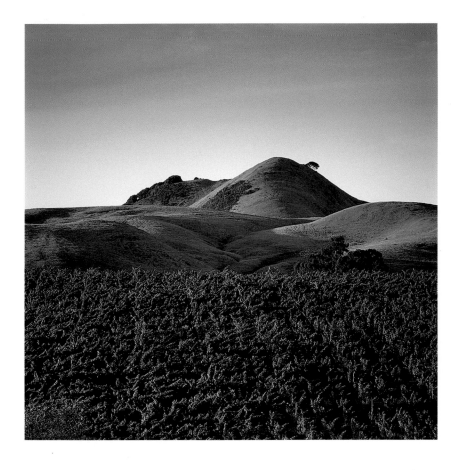

Once used as a cattle ranch, the 100 acres of Roche Carneros Estate Winery now produce premium wines including Chardonnay, Merlot, Pinot Noir, and Syrah. Visitors to the family-run tasting room can enjoy wines along with a tour of the vineyards in a covered wagon.

Gewürztraminer grapes at Kendall-Jackson Vineyard Estates' viticulture exhibit in Fulton. The visitor center has an amazing two-plus-acre organic garden that contains more than 170 varieties of heirloom tomatoes, among other things. *(opposite)*

IF winter is slumber and spring is birth,

and summer is life, then autumn rounds out

to be reflection. It's a time of year when

the leaves are down and the harvest is in

and the perennials are gone. Mother Earth

just closed up the drapes on another year

and it's time to reflect on what's come before.

—Mitchell Burgess, writer,
Northern Exposure

Inside the barrel room at Jordan Vineyard & Winery. The estate was designed by the San Francisco
architectural firm of Backen, Arrigoni & Ross, and was inspired by an 18th-century French châteaux.
The building also houses a wine library, a formal French dining room, and three guest suites.

MAY our love be like good wine,

grow stronger as it grows older.

—old English toast

Rows of vines in Dry Creek Valley.

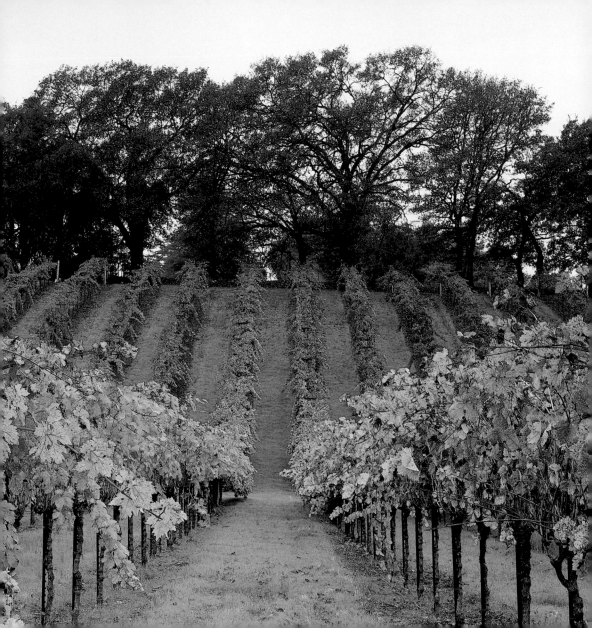

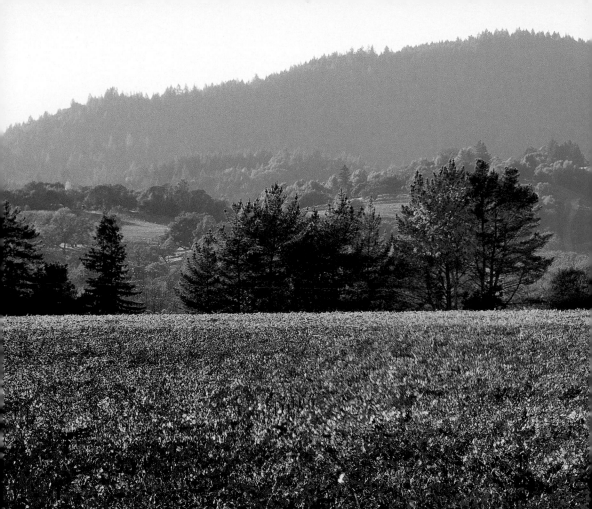

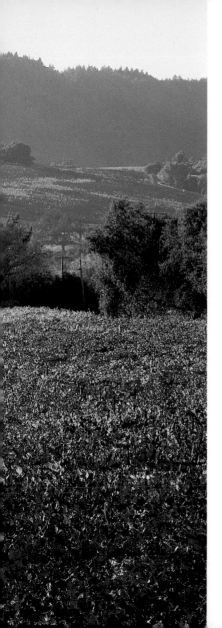

FOR three manic months
each fall, the mood in Wine
County teeters between
agitation and exhilaration;
equilibrium remains elusive. . .
it's a fast tango that has been
taking place for generations,
stubbornly surviving everything
from vineyard pests to Prohibition,
and all set against a transfiguring
landscape of apricot and crimson.

—Meg McConahey,
writer

93

Fall colors set a vineyard ablaze along Eastside
Road in the Dry Creek Valley region of Sonoma.

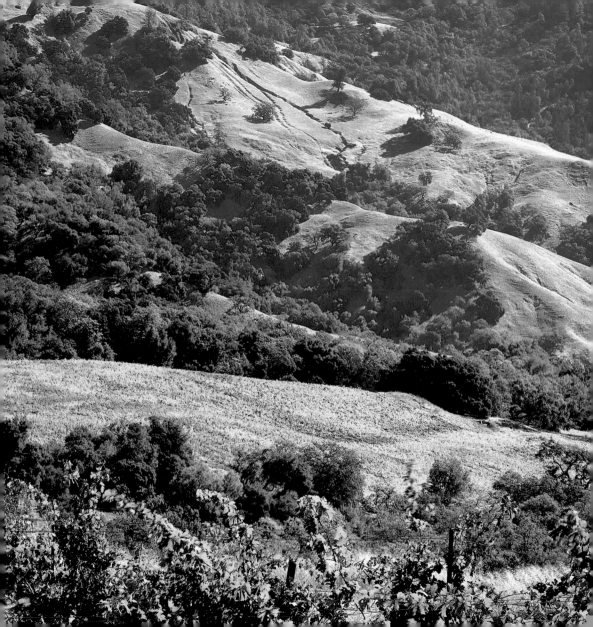

CLIMB the mountains

and get their good tidings.

Nature's peace will flow into you

as sunshine flows into trees.

The winds will blow their

own freshness into you . . .

while cares will drop off

like autumn leaves.

—John Muir

One of the Kendall-Jackson vineyards along Geyers Road. In total, Kendall-Jackson owns more than 12,000 acres along California's coast, growing grapes on mountains, ridges, hillsides, and benchlands.

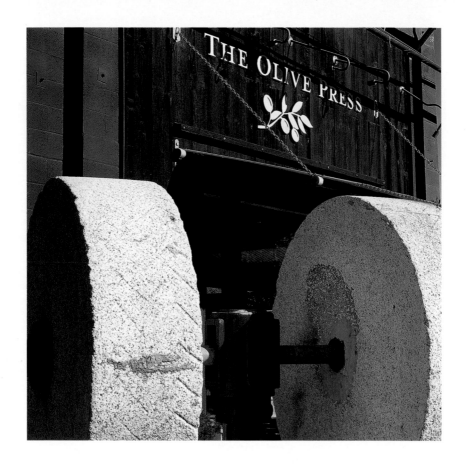

The Olive Press in Glen Ellen was inspired by the olive-pressing cooperatives of Italy and southern France, with features including a Pieralisi press. Commercial producers, growers with small harvests, and hobbyists can all create their own unique olive oil.

Green and purple olives in a picking bin. More than 40 companies in Sonoma County produce olive oil each year. *(opposite)*

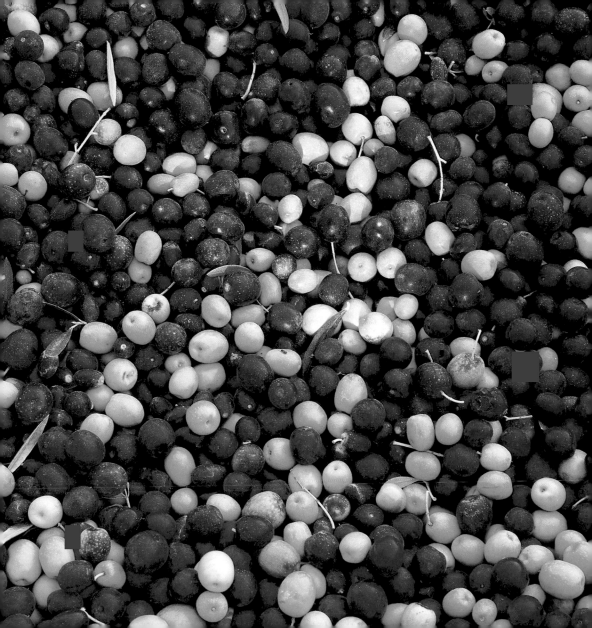

STUDY nature,

love nature,

stay close to nature.

It will never fail you.

—Frank Lloyd Wright

Bright red persimmons grow in Dry Creek Valley. A fruit common in California, the persimmon ripens in late fall, long after its tree has lost its foliage. It can be used to make jam and cakes, or eaten fresh.

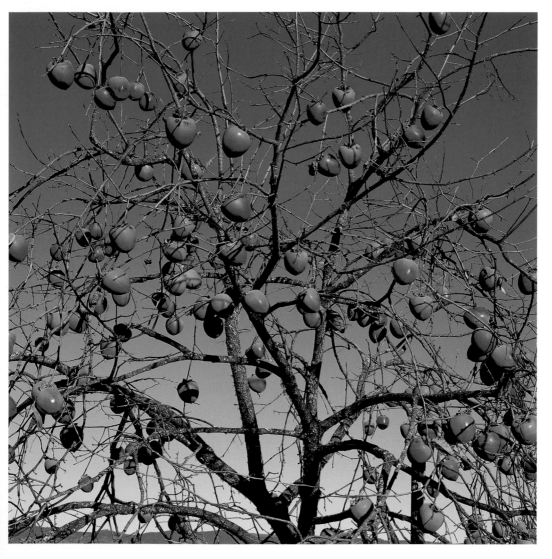

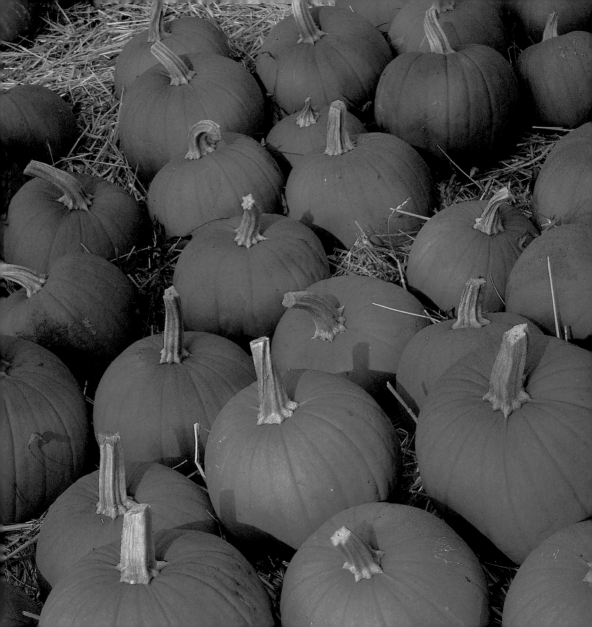

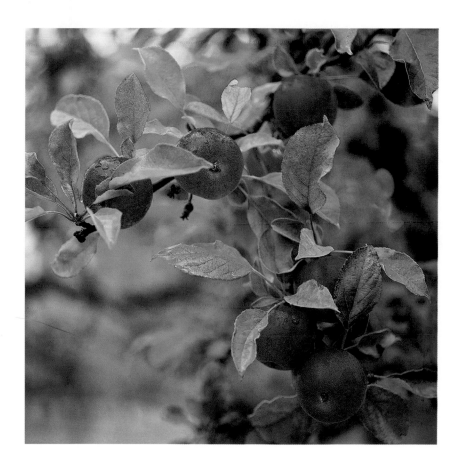

Apples ready for harvest at an orchard in Freestone.

Oak Hill Farm in Glen Ellen owns approximately 200 acres of rolling bottomland—with 45 acres actively farmed— and produces flowers, floral greens, vegetables, fruit, and pumpkins all for sale at the Red Barn Store. *(opposite)*

NOTHING would be more tiresome than eating and drinking if God had not made them a pleasure as well as a necessity.

—Voltaire

The visitor center at St. Francis Winery & Vineyards boasts three separate tasting rooms, along with a dining room, library, and panoramic view of the Wild Oak Vineyard. There are daily Wine and Food Pairing menus, in which the chef offers appetizers to compliment a selection of reserve wines.

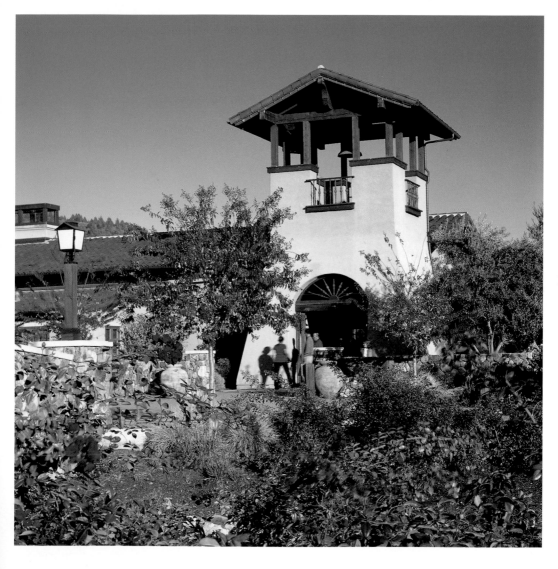

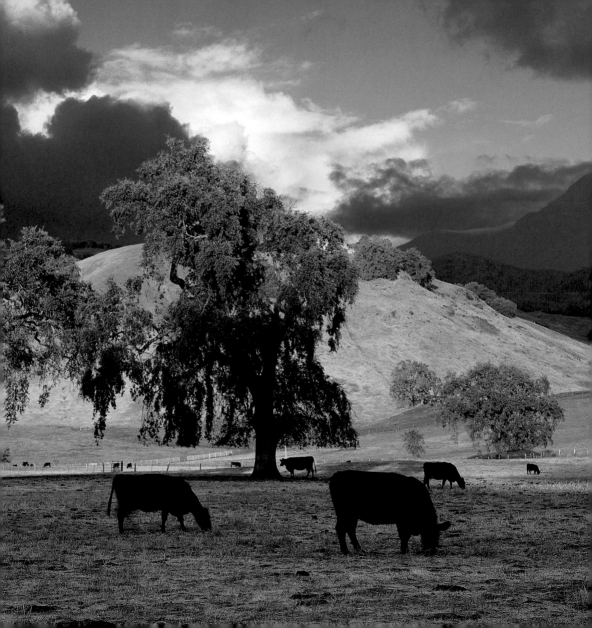

WHEN you combine the
pastoral scene of cows on a
hillside pasture with the dynamic
of world-class vineyards, all with
a background of redwood groves,
you have the makings of paradise.

—Davis Bynum,
vintner

In Knights Valley, Black Angus cows graze and provide a picturesque view. Conservation and open-space programs
protect many of the cattle ranches in Sonoma, ensuring the preservation of the county's rich ranching history.

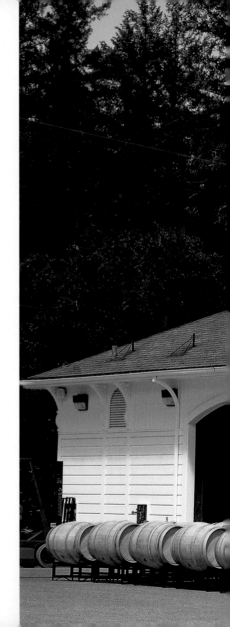

THE rush from vineyard to vat, often racing the rain, defines the season and in many ways the essence of winemaking—the pace, the risk, the role of chance.

—Catherine Barnett,
journalist

Barrels sit outside the Peter Michael Winery in Knights Valley. The vines here grow on the rocky volcanic ridges that form the western face of Mount St. Helena.

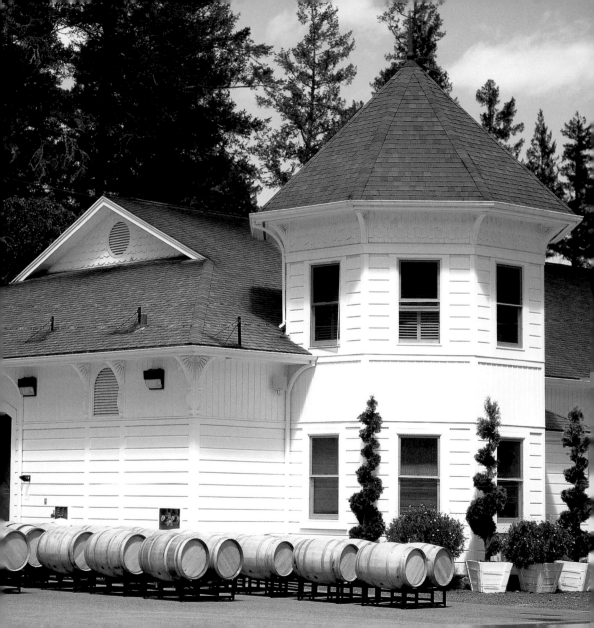

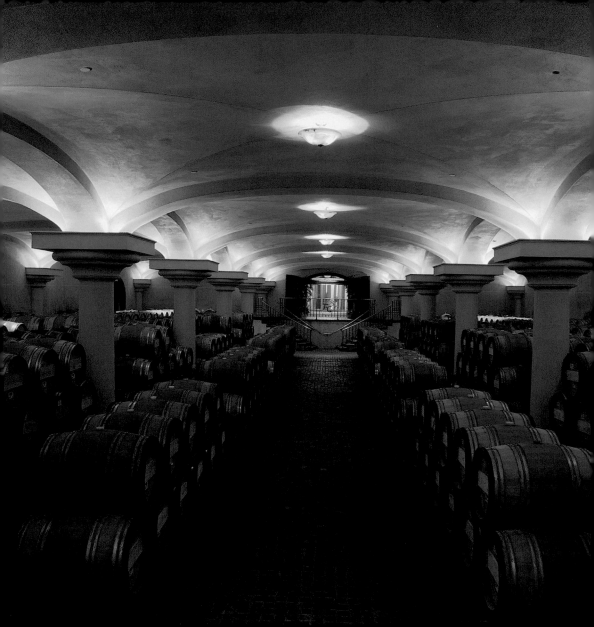

WINE is a living thing.
It is made, not only of grapes and
yeasts, but of skill and patience.
When drinking it remember that
to the making of that wine has gone,
not only the labor and care of years,
but the experience of centuries.

—Allan Sichel,
wine connoisseur

The Barrel Cellar at Ferrari-Carano is just one of the beautiful areas that guests
of the winery can tour. For those who can't make the trip to Dry Creek,
the winery sponsors events around the country that feature a selection of its wines.

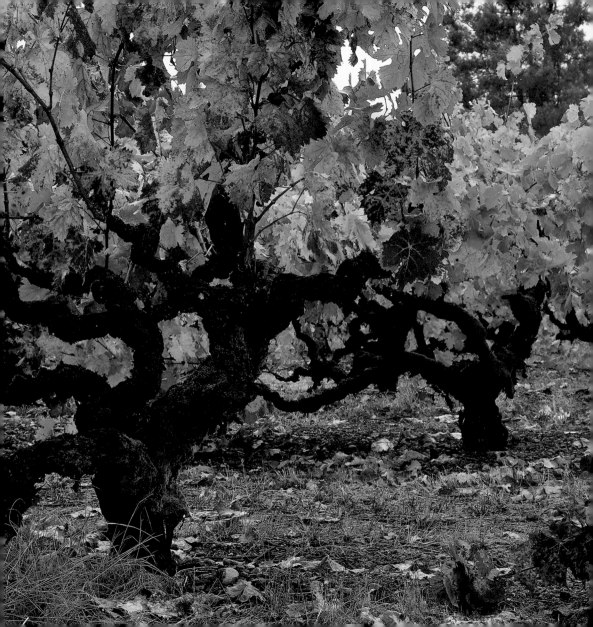

Almost all of the vines at Pagani Ranch were planted more than 100 years ago. The time-tested Zinfandel and Petite Sirah vines have been cultivated by the same family for four generations.

Fall Zinfandel vines at the Pagani vineyard. *(opposite)*

THE sun, with all those plants
revolving around it and dependent
upon it, can still ripen a bunch
of grapes as if it had nothing else
in the universe to do.

—Galileo

Semillon grapes ready for harvest at the Kendall-Jackson Vineyard Estate.
The grapes are used in Kendall-Jackson Vintner's Reserve Sauvignon Blanc.

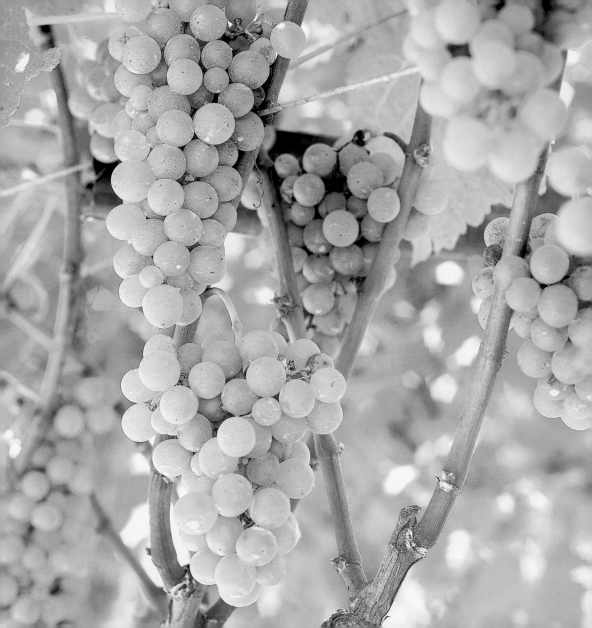

Vines changing at Hanna Winery's Red Ranch vineyard, where Cabernet Sauvignon and Merlot vines are planted.

A large oak tree provides shade for a few vines at Hanna Winery in
Alexander Valley, home to its flagship Merlot and Cabernet wines. *(opposite)*

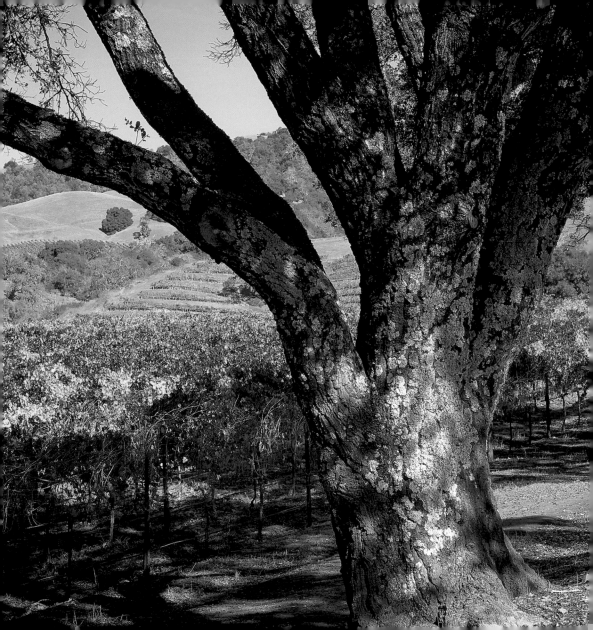

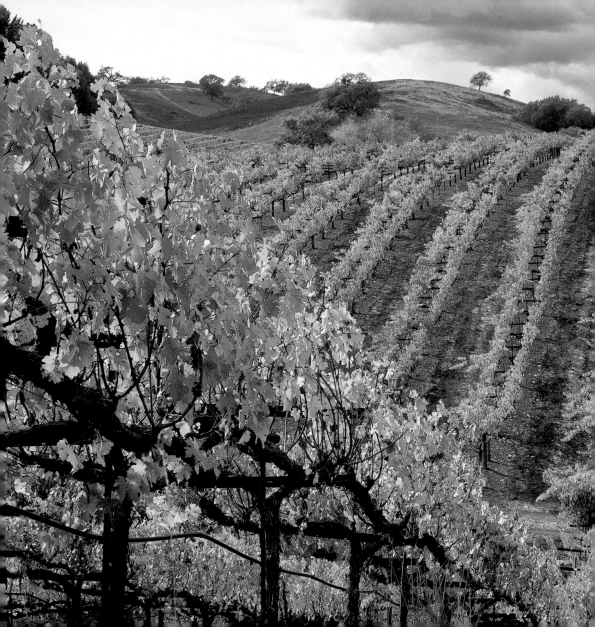

THE scope of the subject of wine is never ending, so many other subjects lie within its boundaries. Without geography and topography it is incomprehensible; without history it is colorless; without taste it is meaningless; without travel it remains unreal. It embraces botany, chemistry, agriculture, carpentry, economics—any number of sciences whose names I do not even know. It leads you up paths of knowledge and by-ways of experience you would never glimpse without it.

—Hugh Johnson,
wine connoisseur

Vines on the rolling hillsides of Sonoma.

An ocean view from Fort Ross State Park on the north coast of Sonoma. The park provides two access points to Sandy Beach and tide pools, as well as an historic orchard with fruit trees planted by Russian settlers. *(overleaf)*

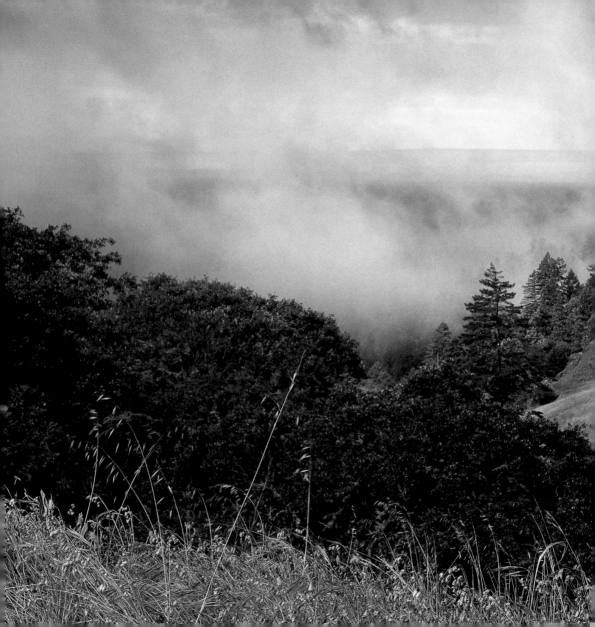

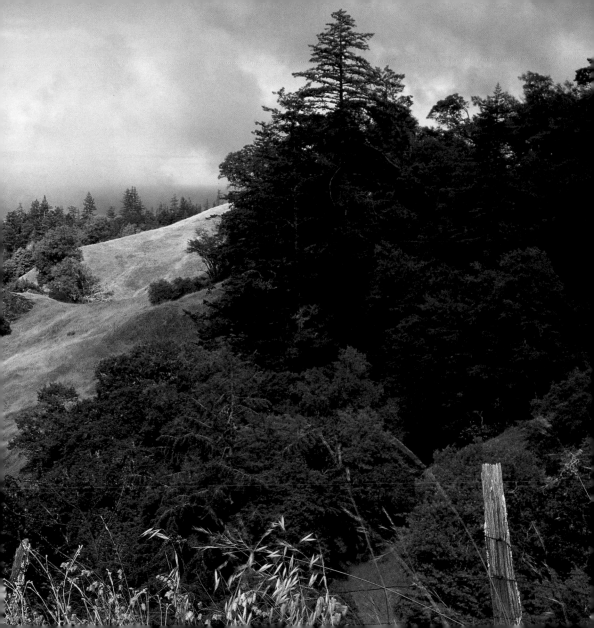

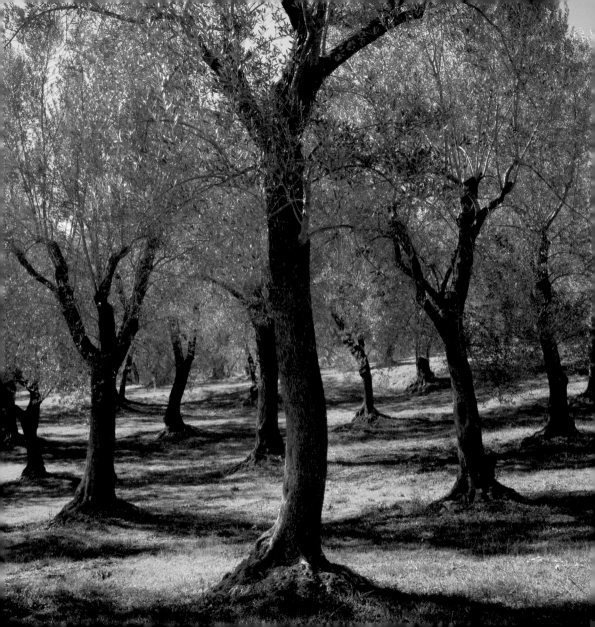

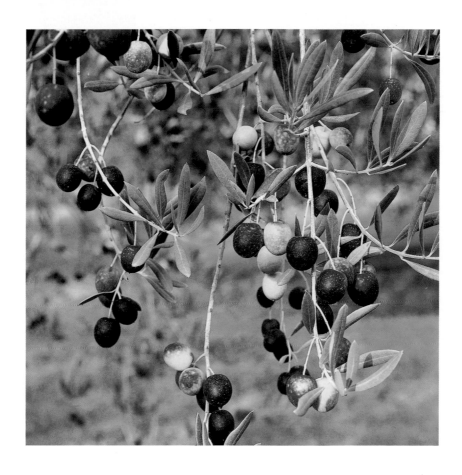

At Bernstein Ranch, ripening olives hang from a tree.

A peaceful path guides visitors through a grove of 130-year-old French Picholine olive trees imported from France in the mid-1800s at B. R. Cohn Winery. Cohn's Olive Hill Estate creates world-class olive oil and vinegars. *(opposite)*

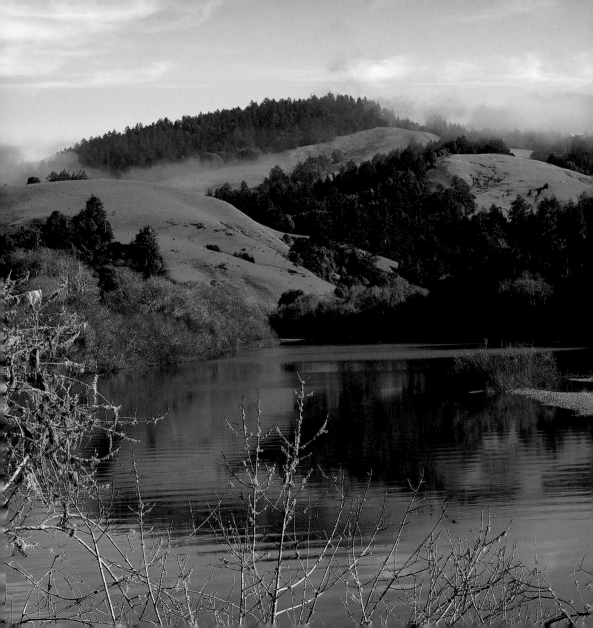

winter

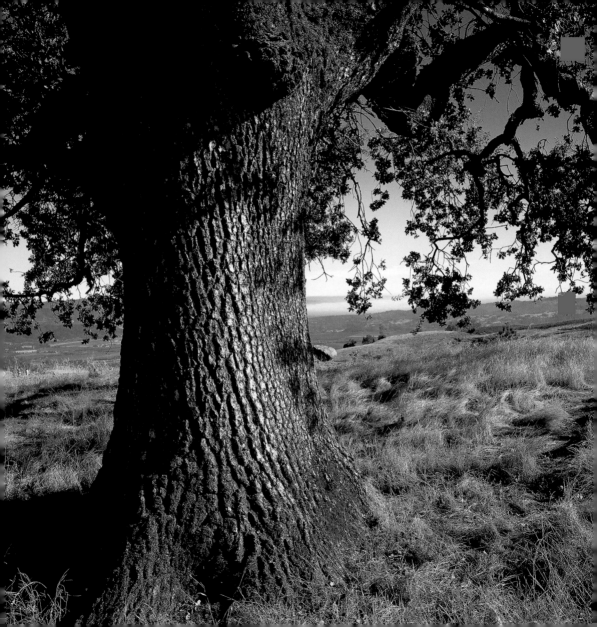

I think there's a greater appreciation of wine by visitors. They're not just talking to some employee when they visit a winery. A lot of times the winemakers are a story unto themselves.

—Fred Slater,
California Division of Tourism

The Russian River winds its way through the small hamlets and towns of Occidental, Rio Nido, Duncan Mills, Monte Rio, Guerneville, and Forestville. *(preceding spread)*

Every January, Kendall-Jackson celebrates crab season by hosting the Crab & Chardonnay Fête, which features local Dungeness crab and wines from its award-winning Chardonnay collection. Another Kendall-Jackson event is the fall Heirloom Tomato Festival, which raises money for the School Garden Network of Sonoma. *(opposite)*

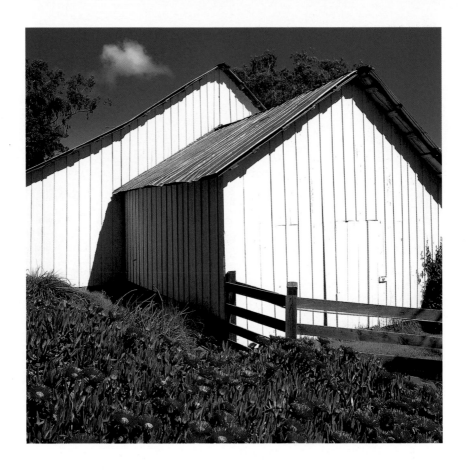

Stillwater Cove Ranch, on the northern Sonoma coast, is a rustic lodge and camping area that makes an ideal setting for abalone divers, kayakers, and vacationing families.

Winter blossoms at Silver Oak Cellars. With two estates fully dedicated to making Cabernet Sauvignon in American-oak barrels, Silver Oak constantly strives to perfect one wine. *(opposite)*

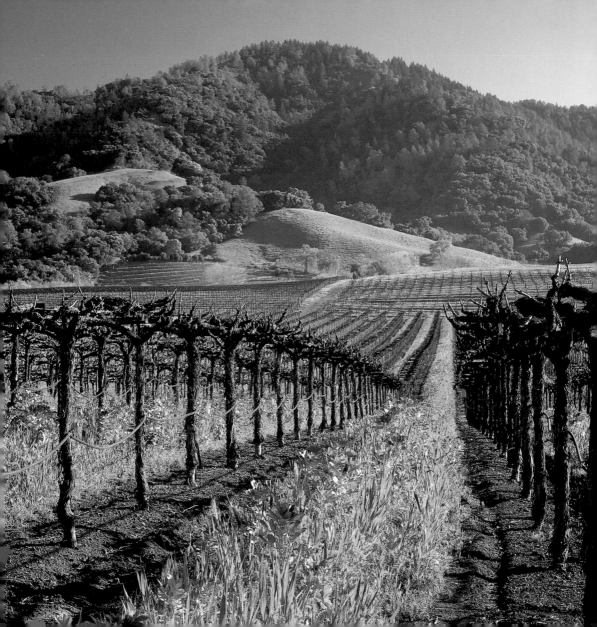

THE new cooking in Sonoma County

became a microcosm of what it was in

California, a patchwork quilt of influences. . . .

The unifying thread and the golden needle,

as it were, that stitched these influences

together was the fertile land itself. . . .

—Michele Anna Jordan,
writer

The Spanish-infused Saffron Restaurant in Glen Ellen offers diners
an extensive wine list including local vintages as well as Spanish varieties.

The town of Petaluma was named for a Coastal Miwok
Indian phrase meaning "valley of little hills." (overleaf)

O Winter! ruler of the inverted year,

. . . I crown thee king of intimate delights,

Fireside enjoyments, home-born happiness,

And all the comforts that the lowly roof

Of undisturb'd Retirement, and the hours

Of long uninterrupted evening, know.

—William Cowper,
poet

The A. Rafanelli Winery in Dry Creek Valley specializes in Zinfandel, Cabernet Sauvignon, and Merlot. Its wines can only be purchased at the vineyard itself.

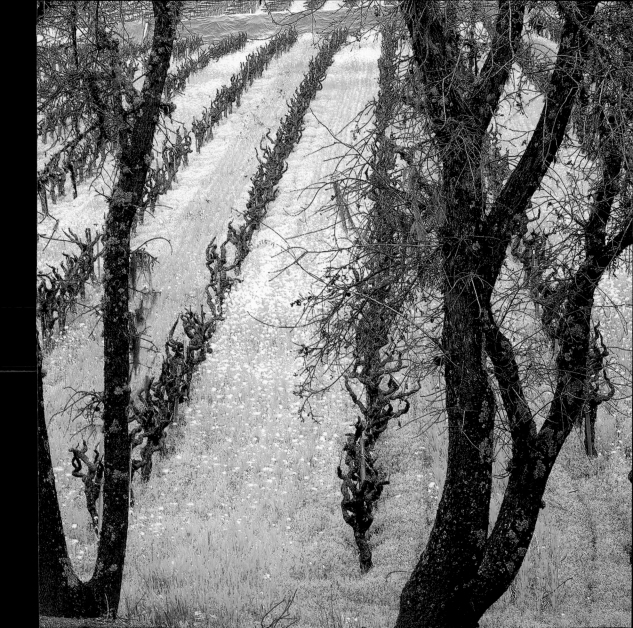

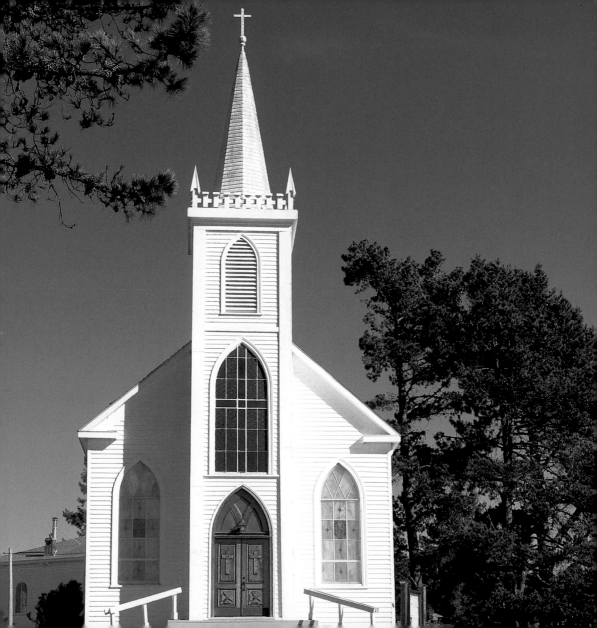

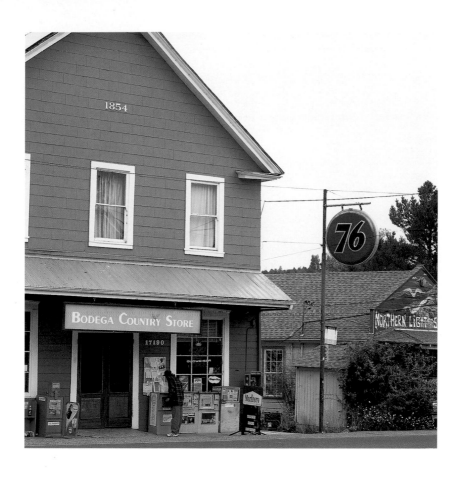

The Bodega Country Store.

The Church of St. Teresa of Avila in Bodega was constructed of redwood in 1859 by New England ships carpenters and is now a California historic landmark. *(opposite)*

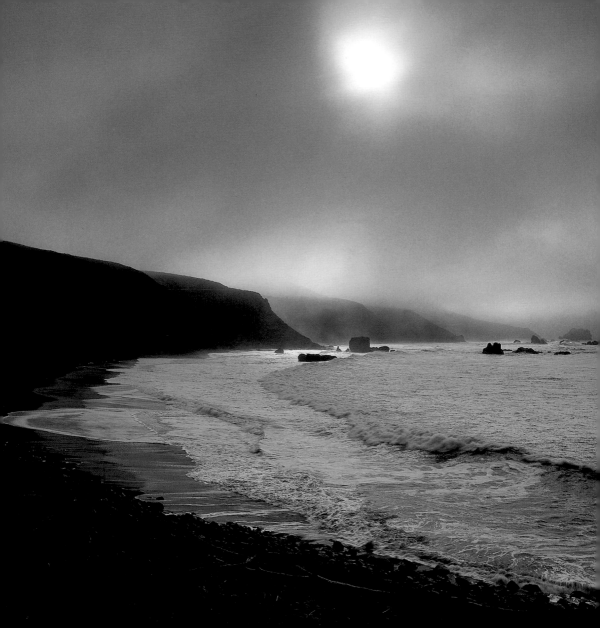

WINE, like the rising sun, possession gains,

And drives the mist of dullness from the brains,

The gloomy vapor from the spirit flies,

And views of gaiety and gladness rise.

—George Crabbe,
poet

Sun breaks through the winter clouds over Sonoma Coast State Beach's Goat Rock.

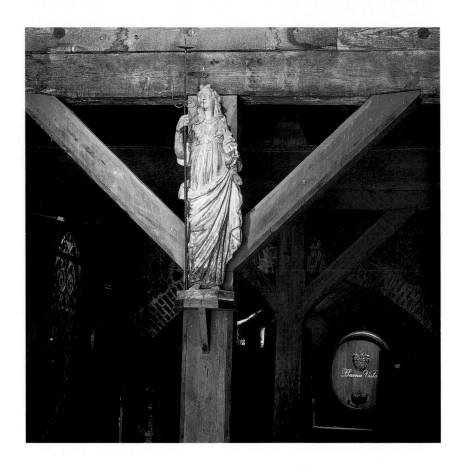

Buena Vista Winery's founder, Count Agoston Haraszthy, arrived in Sonoma County as San Diego's representative to the state legislature. Previously he had been a sheriff of San Diego, founder of the village of Haraszthy Town in Wisconsin, ferryboat owner, and member of the Hungarian Royal Guard.

Founded in Sonoma in 1857, Buena Vista Winery began investing in the Carneros region in 1969 with the purchase of 700 acres of estate vineyards. Its long and moderate growing season matures grapes slowly and evenly to produce the so-called Carneros Quartet: Cabernet, Merlot, Chardonnay, and Cabernet Sauvignon. *(opposite)*

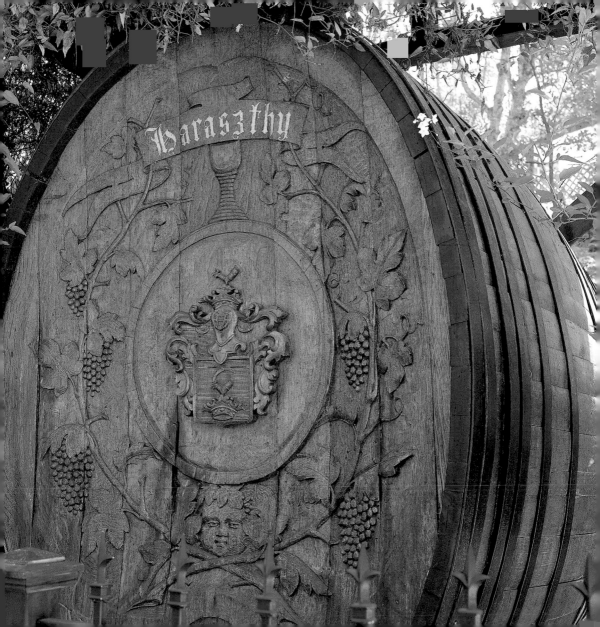

WHEN I am in California,

I am not in the west,

I am west of the west.

—President Theodore Roosevelt

Mission San Francisco Solano—built in 1823 by Father José Altimira—was the 21st and last California mission.

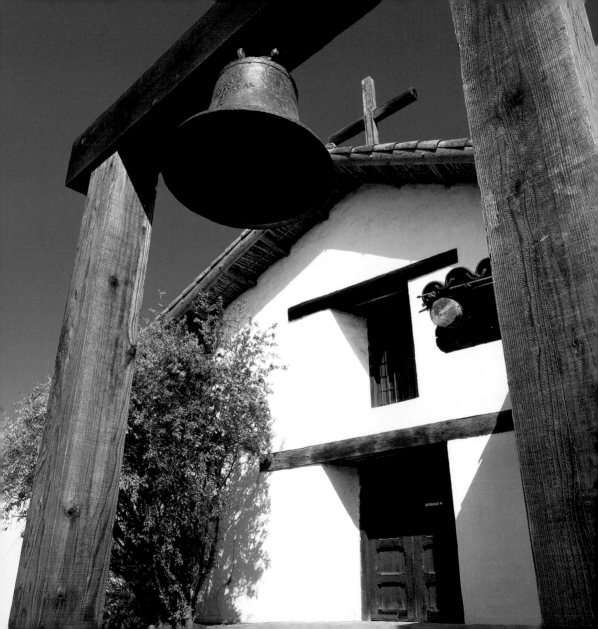

THIS song of mine

Is a song of the vine

To be sung by the glowing embers

Of wayside inns,

When the rain begins

To darken the drear Novembers.

—Henry Wadsworth Longfellow

Lowland fog spreads across Austin Creek State Recreation Area in Guerneville.

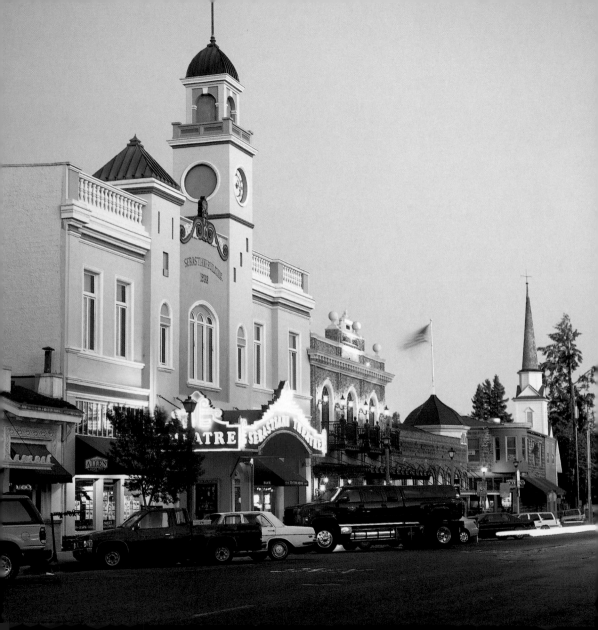

Sebastiani Vineyards & Winery has recently restored its original century-old stone walls and allows visitors to view its famous carved casks. For those who are interested, it also provides historic and open-air trolley tours.

The Sebastiani Theatre in Sonoma was built in 1933 as a movie house. It now offers a wide variety of entertainment, including films, children's theater, and dance performances. *(opposite)*

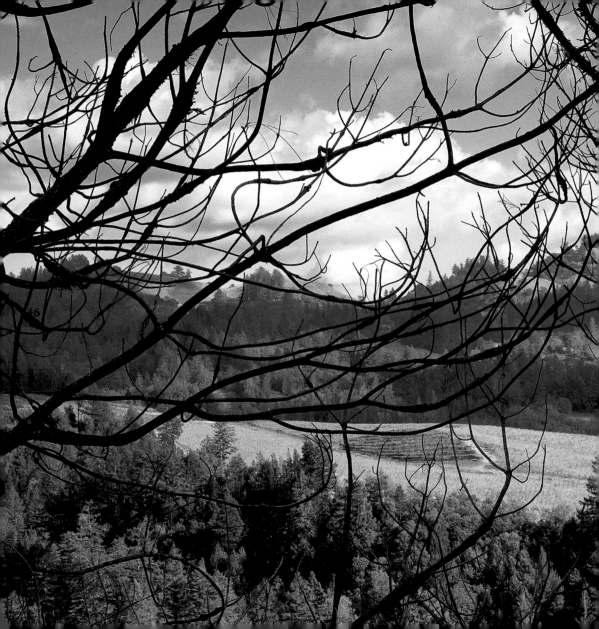

MORE than anything else, it's the general coolness of the valley that gives Pinot Noir and Chardonnay grapes such Burgundian character. The range of flavors in the valley's Pinot Noir wines reflects the differences in soil type, vineyard site and prevailing fog.

<div style="text-align: right">—Rod Berglund,
winemaker</div>

147

A view of Kendall-Jackson's vineyards through winter branches in Knights Valley.

THE miracles of nature do not seem miracles because they are so common. If no one had ever seen a flower, even a dandelion would be the most startling event in the world.

—Anonymous

The Sonoma area provides visitors with a diversity of landscapes, including the majestic Armstrong Redwoods State Reserve in Guerneville.

A. Rafanelli Winery in Healdsburg. *(overleaf)*

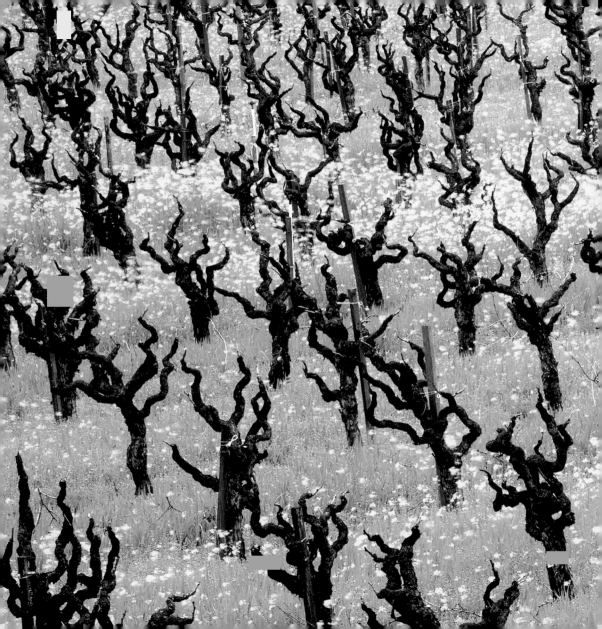

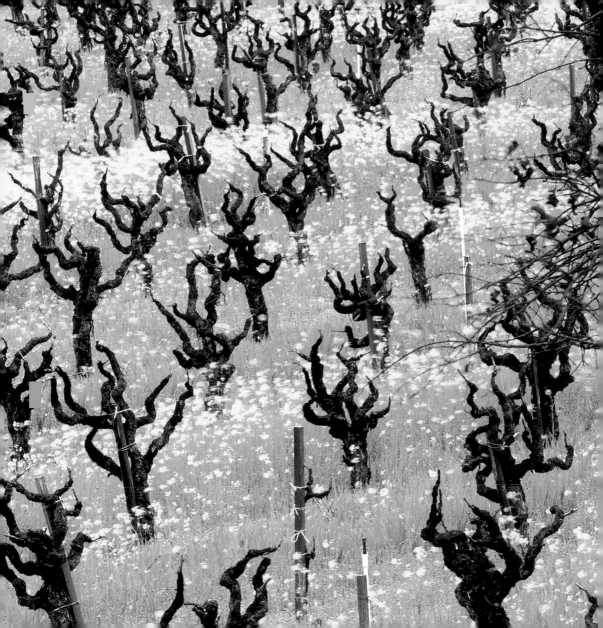

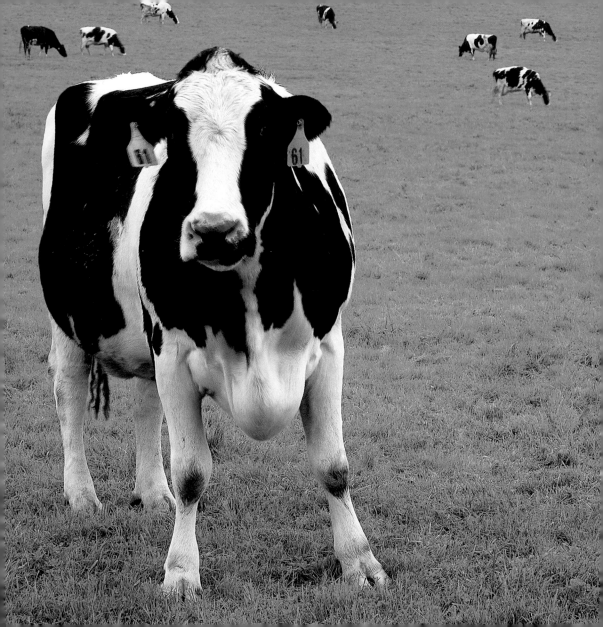

IN all things of nature

there is something

of the marvelous.

—Aristotle

153

Holstein cows graze in Valley Ford. In the
mid-1970s, conceptual artist Cristo was inspired
here to create a 24-mile white-fence Running
Fence, which meandered through the town and
over the hills and ended in the Pacific Ocean.

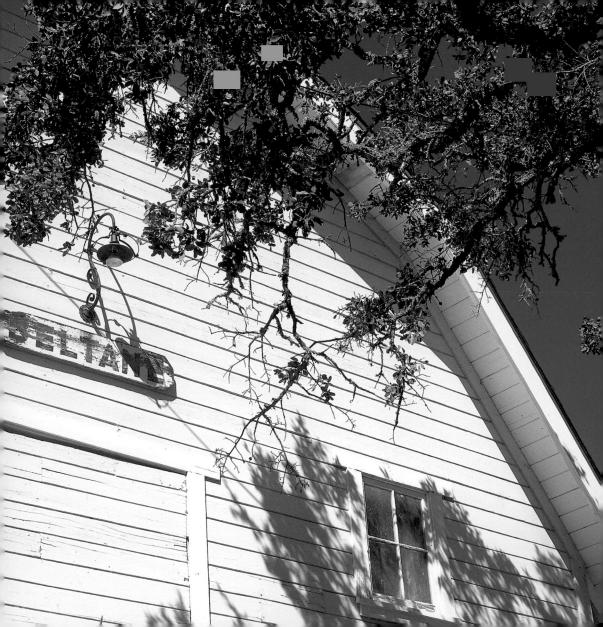

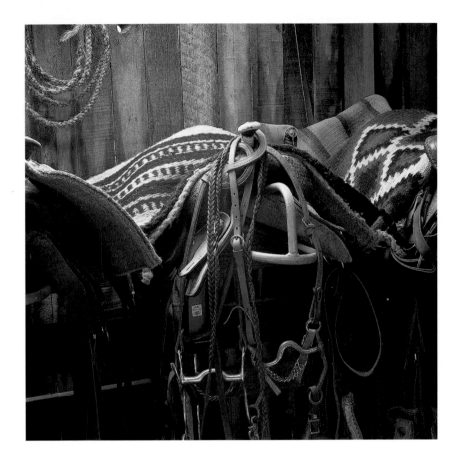

The tack room at Beltane Ranch. Guests at the inn can ride through the
old territory of the Wappo Indians, Mexican settlers, and Jack London's ranch.

The 1890 Beltane Ranch in Glen Ellen, now a bed-and-breakfast, was designed by Mary
Ellen Pleasant. The daughter of slaves and a legendary figure in old San Francisco, Pleasant
was known for her work with abolitionist John Brown and the Underground Railroad.
The architecture and landscape of the inn reflect her New Orleans heritage. *(opposite)*

156

Wright's Beach at the northern end of the Sonoma Coast State Beach.

The Pacific Ocean meets Sonoma County at the Sonoma Coast State Beach. This strand stretches more than 17 miles—from Bodega Head up to Vista Trail—and is one of the Northern California's most beautiful attractions. *(opposite)*

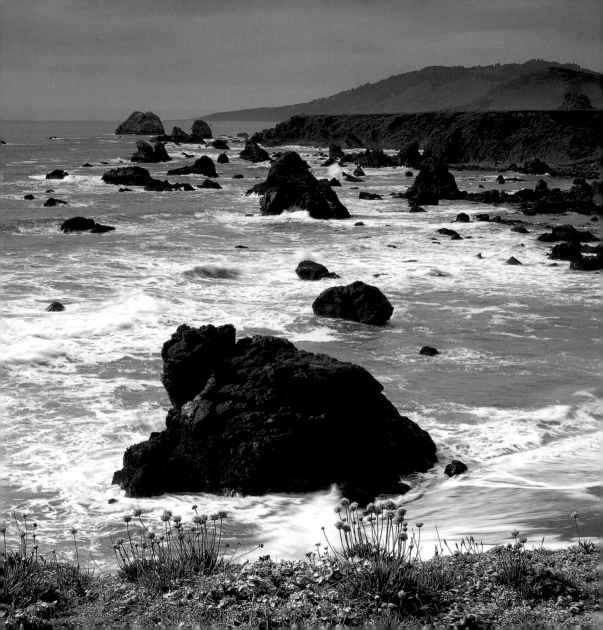

FIRST you must hold your glass
to the light and swirl the wine slowly
to study its color. Then you bring
the glass to your nose to breathe the
wine's bouquet. And then, you set your
glass down and you talk about it.

—Charles-Maurice de Talleyrand-Périgord,
French diplomat

Old Vine Zinfandel in Crystal Brook Vineyard.

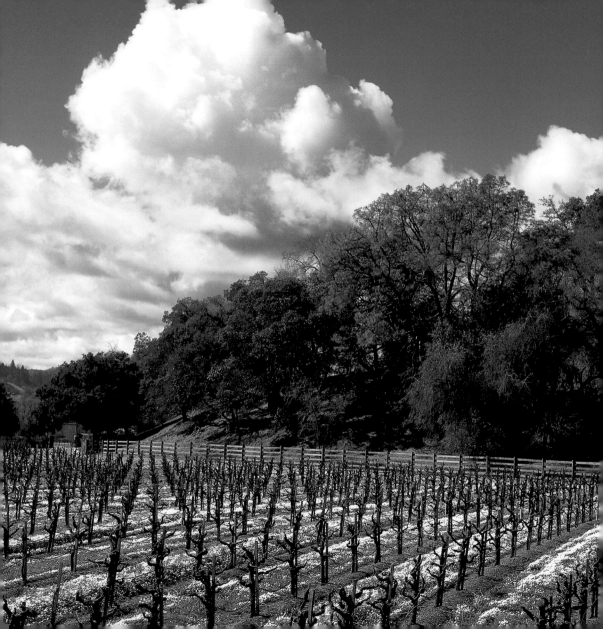

Published in 2006 by Welcome Books®
An imprint of Welcome Enterprises, Inc.
6 West 18th Street, New York, NY 10011
(212) 989-3200; Fax: (212) 989-3205
www.welcomebooks.com

Publisher: Lena Tabori
Art Director: Gregory Wakabayashi
Designer: Naomi Irie
Project Manager: Natasha Tabori Fried
Editorial Assistant: Maren Gregerson

Library of Congress Cataloging-in-Publication
Data

Walker, Wes.
 Hidden Sonoma / photographs by wes walker.--
1st ed.
 p. cm.
 Includes bibliographical references and index.
 ISBN 1-932183-92-2 (hardcover : alk. paper)
 1. Sonoma County (Calif.)--Pictorial works. 2.
Vineyards--California--Sonoma County--Pictorial
works. 3. Sonoma County (Calif.)--Quotations,
maxims, etc. I. Title.
 F868.S7W35 2006
 979.4'18--dc22
 2005035891

ISBN-13: 978-1-932183-92-4
ISBN-10: 1-932183-92-2

Printed in China
First Edition
10 9 8 7 6 5 4 3 2 1

Started in 1931, the Vella Cheese Company has become one of Sonoma's oldest and most famous local
businesses. Vella produces top-quality artisan cheeses ranging from Monterey Jack to Cheddar to Asiago.